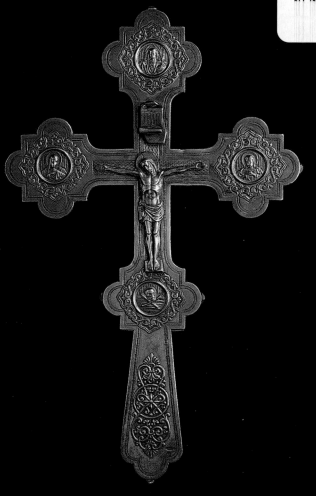

НЕБО НА ЗЕМЛЕ

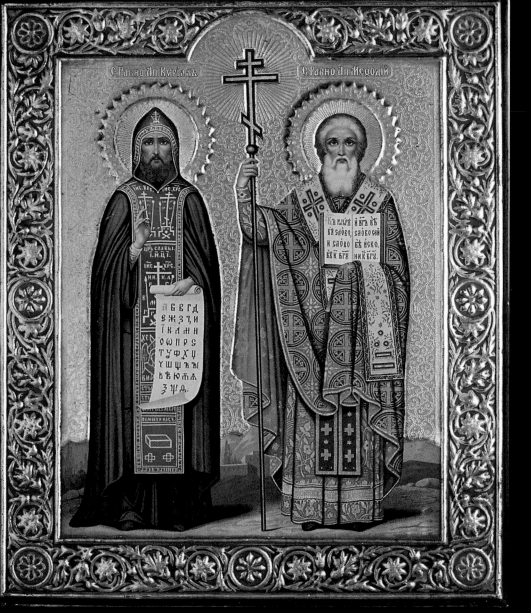

FOREWORD

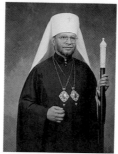

It is my great pleasure to write the foreword for this catalogue displaying many icons and sacred objects used in the Orthodox Church. The exhibit, *"Heaven on Earth,"* coincides with the 200th anniversary celebration of the founding in 1794 of the Orthodox Church on the North American continent.

Indeed, the bicentennial of Orthodox Christian faith in the Western Hemisphere, through the items displayed in this exhibition, provides the appropriate context to address the relationship which exists between Christianity and culture and its impact on the missionary activities of the Orthodox Church.

From the beginning the Church sought to be faithful to the command of the resurrected Christ to make disciples of all nations (Mt 28:19). The Russian mission which arrived on Alaskan soil in 1794 was comprised of eight monks and two novices. The seed of faith planted by their efforts and its subsequent growth attests to the universality of Christianity and the fact that all culture is to be a living context for the Orthodox Church.

Initially coming to Alaska in order to tend to the spiritual needs of those Russians who had crossed the Bering Sea seeking adventure and fortune, the Orthodox mission immediately offered itself to the indigenous Americans.

At the same time, the mission stood opposed to all political and colonial motives of the existing civil authorities. Its primary objective was not *Russification* of the Alaskan Native but the proclamation of the Gospel of Christ to all who desired to listen. It is this fundamental agenda of calling everyone and everything to sanctification and transfiguration that provides the theological basis for mission. And it is this agenda of *metamorphosis* which liberates both the missionary and the missionized from making culture an end in itself. Thus, not seeking to destroy the culture of the Alaskan Native, the Orthodox missionaries offered the possibility of inner transformation, which would eventually reveal itself in the existing culture as something new.

The survival of the mission depended to a large extent on the efforts of individual and unique missionaries. It was largely through the inexhaustible efforts of Priest John Popov (revered today by the Orthodox faithful as St. Innocent Veniaminov) that the Alaskan mission would realize its force and vision. St. Innocent began his missionary activity as a married parish priest and later, after the death of his wife, Katherine, was consecrated bishop in St. Petersburg on 15 December 1840. He was given the title, Bishop of Kamchatka, the Kurile and Aleutian Islands. The episcopal see was located in

HEAVEN ON EARTH

Orthodox Treasures of Siberia and North America

Barbara Sweetland Smith

David J. Goa

Dennis G. Bell

Foreword by
Metropolitan Theodosius
Archbishop of Washington, D.C.
Primate, Orthodox Church in America

Edited by Barbara Sweetland Smith with assistance by Mina A. Jacobs
Anchorage Museum of History and Art
1994

(Frontis 1)

Blessing Cross — Russia, n.d.
Silver, chasing on both sides,
25.5×15.2 cm. St. Michael
Cathedral, Sitka, Alaska

Father John Veniaminov
(Bishop and St. Innocent) used
this small cross when he served
as Bishop in Sitka. It is held by
the priest or bishop and used to
bless the congregation. At the
conclusion of the Eucharist, the
congregation comes forward to
kiss the cross as it is held by the
officiant. (Cat. 81)

(Frontis 2)

Icon: Sts. Cyril and Methodius
— Moscow, Russia, 1898. Iron,
ink, paint, wood, textile, gilding,
27×31 cm. Church of St. George
the Victorious, St. George,
Alaska

A Russian inscription before
each saint's name reads, "equal
to the Apostles." This icon of
the Greek missionaries who
brought Christianity and the
Cyrillic alphabet to the Slavic
peoples is typical of many icons
in village churches, being
lithographed pressed metal.
(Cat. 114)

(Frontis 3)

**Icon: Virgin of Sorrows
(Dolorosa)** — By the hand of
Hieromonk Timotei Tohaneanu,
1970s. Sambata Monastery,
Romania. Glass, paint,
53.5×43.5 cm. George
Dobrea, Cleveland, Ohio

Icons on glass are an art form
identified primarily with
Transylvania. The technique
developed in the 17th and 18th
centuries and was intended for
use in homes by the rural popu-
lation. It subsequently became
a unique way for the Romanians
to express their cultural identity
within the Austro-Hungarian
Empire. The form was used into
the early 20th century and is
being revived today. The
"Dolorosa" is the most popular
icon of this genre. (Cat. 197)

Published on the occasion of the exhibition
Heaven on Earth:
Orthodox Treasures of Siberia and North America
(May 12-October 24, 1994)
organized by the Anchorage Museum of History and Art
celebrating the Bicentennial of Orthodox Christianity in North America

©1994
Anchorage Museum of History and Art
121 West Seventh Avenue
Anchorage, Alaska 99501

ISBN 1–885267–00–2

TABLE OF CONTENTS

FOREWORD vi
His Beatitude Metropolitan Theodosius

PREFACE viii
Patricia B. Wolf, Director

ACKNOWLEDGEMENTS ix

DONORS AND SPONSORS xi

INVITATION TO THE FEAST: 1
The Orthodox Mission in North America
Barbara Sweetland Smith

LITURGY, THE ART OF ARTS 41
David J. Goa

HOLY ICONS — THEOLOGY IN COLOR 63
Dennis G. Bell

CHRONOLOGY 85

GLOSSARY 109

LENDER LIST 114

New Archangel (Sitka), and through his efforts the Alaskan mission achieved administrative stability.

Soon after Alaska was sold to the United States in 1867, Bishop Innocent became Metropolitan of Moscow. He continued to maintain an interest in the Church in America and continued to foster a vision for the direction it was to take. In a letter to D.A. Tolstoy (Head of the Holy Synod) dated 5 December 1868, Metropolitan Innocent wrote the following: "It reached my attention from Moscow that I allegedly wrote to someone saying that I was not pleased that our American colonies had been sold to the Americans. This is completely untrue. On the contrary, I see in this event one of the ways of Providence by which our Orthodoxy can insert itself into the United States." What follows in this prophetic letter is a list of suggestions for the future growth and development of the Church in America. Among these suggestions was the need for an English-speaking bishop and the establishment of pastoral schools to train English-speaking priests.

It was on 10 June 1870 that the formation of an American diocese was realized. Archimandrite John Mitropolsky, a former instructor of the Moscow Theological Seminary, was consecrated bishop of the newly established Diocese of the Aleutians and Alaska. In 1872 the diocesan see was transferred from Sitka to San Francisco. This move indicated that the Church was growing more aware of its responsibility to unify Orthodox immigrants of various ethnic backgrounds who settled on the West Coast. Establishing the episcopal see in San Francisco also indicated that the Church was also reaching out to those Americans of various ethnic backgrounds who were seeking the consolation of Christ.

During the episcopate of Bishop Tikhon (Belavin) in 1905 (revered today as St. Tikhon by the Orthodox faithful) the episcopal see moved from San Francisco to New York City. Five years prior to this move another significant event had occurred. When Bishop Tikhon was elevated to the rank of archbishop in 1900, the name of his diocese was changed from the "Aleutians and Alaska" to the "Archdiocese of the Aleutians and North America."

The work of the original Orthodox mission continues to this day in Alaska and across North America. Transformation of culture is for the Orthodox an ongoing historical endeavor. What the local Church in America received from the monks who came to Kodiak and from subsequent missionaries is a legacy that emerges from the very heart of the Gospel. It is these God-enlightened visionaries who, being faithful to their task, maintained the necessary tension of the Church being *in* and *for* the world but *not of* the world. May the spirituality and beauty conveyed by the liturgical objects in this exhibit inspire you and bring you to an understanding of the 200-year legacy of the Orthodox Church in North America.

<div align="right">

THEODOSIUS
Archbishop of Washington
Metropolitan of All America and Canada
Primate, Orthodox Church in America

</div>

PREFACE

"...the Greeks led us to the buildings where they worship their God, and we knew not whether we were in Heaven or on earth. For on the earth there is no such splendor or such beauty, and we are at a loss to describe it. We know only that God dwells there among men..."

This remarkable quotation is part of the report of the emissaries of Grand Prince Vladimir of Kiev as they returned from Constantinople. Vladimir was persuaded to accept Christianity for all Rus'. The beauty and ritual of the services captivated the Russians in 988 and has endured for centuries.

We have used that phrase "Heaven On Earth" to describe the beauty and wonder that still calls to us in a different time and place as we celebrate the bicentennial of Orthodox missionary activity in Alaska.

Those of us who live in a world saturated by print and electronic media can easily forget that there was a time when books were rare and the average person could not read. Over the centuries the liturgical life of the Church became a great vehicle of communication as the story of the faith was told through the hymns, the spoken word and the visual images of the Church. We call these tangible images liturgical art and one can sense the beauty and power of the faith as interpreted in icons, vestments, tapestries and the altar pieces of gold and brass.

This exhibit seems a perfect fit for our institution as a museum of history and art. One cannot recount the history of Alaska without reference to the pioneer Orthodox missionaries and one cannot begin to understand the Orthodox faith apart from its liturgical life.

When the decision was made to mount this exhibit, I called on Alaskan historian and writer Barbara Sweetland Smith, to serve as the exhibit curator. Barbara had served as curator for the exhibit *Russian America: The Forgotten Frontier* that our museum organized in 1990. Through her extensive network of contacts we have received a superb response from a host of Orthodox communities throughout North America who have shared the treasures of their faith. This exhibit has been enriched by the addition of over 70 objects on loan from the Irkutsk Regional Museum in Siberia. We have a strong historical tie to Irkutsk since this is the parent diocese that began missionary activity to Alaska and later to North America.

We trust that you will be moved by the exhibit and gain insights from the essays in this catalog that will help you understand the "mystery of faith" that is so central to the Orthodox tradition and that you will be inspired to learn more about the land, the people and the ideas that have shaped Alaska.

Patricia B. Wolf, Museum Director

ACKNOWLEDGEMENTS

This book accompanies a major exhibit, *"Heaven on Earth: Orthodox Treasures of Siberia and North America."* The organization of the exhibit and the production of this catalog involved the time and talents of many individuals and organizations which we would like to acknowledge with gratitude.

It will be noticed from the list of lenders at the back of the catalog that most of those who contributed items for the exhibit were churches. They have parted with treasures which are a vital part of their liturgical life. We recognize the sacrifice of such loans and wish to thank the parishioners and the following church officials and clergy for their invaluable support and advice: In particular, we thank most warmly His Beatitude Metropolitan Theodosius, Archbishop of Washington, D.C. and Primate of the Orthodox Church in America (OCA) for his help at every stage in the planning of the exhibit and for making a number of special items available from the Chancery. Of the many others who were especially generous, we would like to mention particularly The Right Rev. Gregory, Bishop of Sitka and Alaska, whose enthusiasm at the outset not only brought a number of wonderful objects from the Cathedral of St. Michael in Sitka, but encouraged other churches in Alaska to follow suit. Other clergy who deserve special mention are: Bishops Herman of Philadelphia, Job of Chicago, Nathaniel of Detroit, Tikhon of the West, Very Rev. Dean Thomas Hopko of St. Vladimir's Theological Seminary, Deacon Christopher Calin (New York City), Rev. Remus Grama (Cleveland), Rev. John Tkachuk (Montreal), Rev. Victor Sokolov (San Francisco), Very Rev. Protopresbyter Joseph P. Kreta (Kodiak), Very Rev. Eugene Bourdukovsky (Sitka), Rev. Wasilie Askoak (Old Harbor), Rev. Sergie Active (Kenai), Rev. Michael Oleksa (Juneau), Very Rev. Nicholas Molodyko-Harris (Anchorage), Sub-deacon Andronik P. Kashevarof, Sr. (St. George, Alaska), Rev. Nicholas Jonas (New Orleans), Rev. Demetrius Couchell (St. Photius National Greek Orthodox Shrine), Right Rev. George Geha (Antiochian Village), and Rev. William Rhodes (San Francisco). We also acknowledge the help of Zenia Borenin and the Parish Council of Akutan, Alaska; David Gregory and the Parish Council of Unalaska; and Dorothy McCard and the Parish Council of Kenai.

Several individuals acted as coordinators-on-site from lending institutions and spent many hours working on behalf of the exhibit. We appreciate the efforts of Alexis Liberovsky, Archivist, Orthodox Church in America; Kenneth Johnson, St. Vladimir's Orthodox Theological Seminary; and Virginia E. Martin, Curator, Romanian Folk Art Museum, Cleveland. All Chicago-area objects

were made available through the efforts of Gordana Trbuhovich, Christian Synergy, Department of Public Affairs, Chicago, Illinois. Svetlana Thomson and Maria Sakovich helped arrange the loans from the San Francisco area.

The formation of *"Heaven on Earth..."* began with the loan of a number of beautiful liturgical objects from the Irkutsk Regional Museum. We are grateful to Ludmila M. Kolesnik, Director, and her staff for their assistance in helping us launch this exhibit. Special thanks are extended to Svetlana Anchutina, Scientific Secretary, who has kept communication between our museums active and who worked diligently gathering the documentation for the Siberian section of the exhibit. Other Siberians whose help was invaluable include Oleg Bychkov, Director, Ethnographic Bureau, Irkutsk, who first suggested the exhibit when he brought material from Irkutsk for the *"Russian America"* exhibit, and also acted as host and resource person for Anchorage Museum staff in Irkutsk; Archpriest Sergei Kuznitsov, of the Cathedral of the Sign, Irkutsk, who was a consultant on the Siberian material; Vladimir E. Guliaev, photographer; and Alexsei Iziur'ev, who facilitated the visit to Irkutsk of our museum staff.

Many people have volunteered their talents to assist with the exhibit and the catalog. Special acknowledgement is extended to Ayse Gilbert for design and layout of this catalog; to Byron Birdsall who designed the exhibit poster using his own original icon of St. Innocent, Apostle to Siberia and America; to Jacquie Clark and Natasha Strelkova who provided translation services; to Barbara Geib who prepared expert condition reports as the objects entered the museum; to Nancy Krebs for proofreading; and to Lynn Birdsall for assistance with the catalog layout.

Several of our museum and association staff deserve special mention: Mina Jacobs, Assistant Archivist, has worked many extra hours for over a year as the primary contact with the Irkutsk Museum and as chief translator for the project; Walter Van Horn, Curator of Collections, coordinated the shipment and receipt of the objects in the museum; Janelle Matz worked closely with the couriers from Irkutsk in preparing condition reports for the Siberian material; Alan Shayer created masterful crates for shipping the treasures; Dave Nichols, Curator of Exhibits, captured the timeless beauty of Orthodox liturgical life in his design and installation of the exhibit; Sharon Abbott has coordinated publicity and education for the exhibit; and Walter Hays, Development Officer of the Anchorage Museum Association, has made new friends for the museum as he has developed a broad base of private support in his fundraising efforts for the exhibit.

Patricia B. Wolf, Director

Donors

The Anchorage Museum of History and Art and the Anchorage Museum Association gratefully acknowledge the generous support that has made this exhibit possible.

Sponsors:

SAFECO Insurance Companies

ARCO Foundation, ARCO Alaska, Inc.

Heery International, Inc.

Kreielsheimer Foundation

Oceantrawl Inc.

USX Foundation/Marathon Oil Company

Alaska Humanities Forum

Bank of America

Additional Support:

Aeroflot International Airlines, Anchorage Museum Association, Ayse Gilbert Graphic Design, Bristol Bay Native Corporation/Anchorage Hilton Hotel, Fluor Foundation, Echo Bay Mines, Ltd., ERA Aviation, PenAir, Siberia Alaska Trading Company, Northern Printing

Patrons:

Akutan Corporation, The Aleut Corporation, Richard L. Day, D.D.S., ECI/Hyer, Inc., Hugh and Lanie Fleischer, NW Marine Electrical, Ounalaska Corporation, Kenneth T. Richardson, M.D., St. George Tanaq Corporation, Floyd V. Smith, Warren and Sally Suddock, Francine Taylor

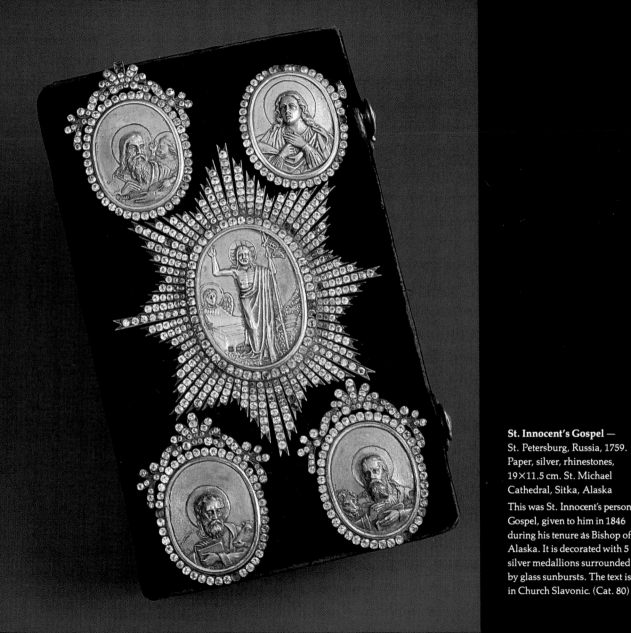

St. Innocent's Gospel —
St. Petersburg, Russia, 1759.
Paper, silver, rhinestones,
19×11.5 cm. St. Michael
Cathedral, Sitka, Alaska

This was St. Innocent's personal
Gospel, given to him in 1846
during his tenure as Bishop of
Alaska. It is decorated with 5
silver medallions surrounded
by glass sunbursts. The text is
in Church Slavonic. (Cat. 80)

"Then He said to them, "Go forth to every part of the world, and proclaim the Good News to the whole creation". . . and they went out to make their proclamation everywhere.
Mark 16:15–20

INVITATION TO THE FEAST:
The Orthodox Mission in North America

Barbara Sweetland Smith

The Orthodox Church is one of America's important cultural institutions. It is the spiritual home for some three million Greeks, Russians, Syrians, Lebanese, Romanians, Serbs, Albanians, Bulgarians, Ukrainians, Carpatho-Russians, Aleuts, Eskimos, Tlingits and Athabascans, as well as many others who claim the usual American mixture of traditions. Separated by national or ethnic inheritance, these people all share in the common experience of the Orthodox Communion. This community of faith and practice derives from the ancient church of Byzantium, the eastern branch of Christendom, which split with Rome over theological and political issues in the 11th century. Centuries earlier, missionaries from Greece had brought Christianity in the 9th century to Serbia and Bulgaria, offering the Christian message in Slavic, the language of the people and developing alphabets and translations as they went. In 988, Grand Prince Vladimir of Kiev was persuaded to accept Christianity when told by his trusted advisors that the services they had witnessed in Constantinople (Byzantium) were "Heaven on earth."

The beauty, message, and ritual of the services captured the mind and soul of the Russians as they have many others in far-flung missionary fields, reaching all the way to the western shores of America.

Although united in belief, the Orthodox Church in the United States and Canada today presents a many-faceted image, not unlike the multi-national character of North America itself. There is not one Orthodox Church, but several. The Serbian and Greek Churches have their own administrations and their American bishops follow the lead of patriarchs in Belgrade and in Constantinople. The Orthodox of Middle Eastern background — mostly Lebanese and Syrian — are under the jurisdiction of the Patriarch of Antioch. Russians present a more complex picture. The greatest majority of Russian Orthodox in the U.S. today call the Orthodox Church in America (OCA) their spiritual home. The OCA is completely independent of the Russian church and is headed by the Archbishop of Washington, D.C., Metropolitan

Theodosius (Lazor) who is American-born. It is the direct heir of the Alaska mission which established Orthodoxy in North America in 1794. Despite its Russian roots, it now seeks to be inclusive of Orthodox of many nationalities — and no particular nationality. The Romanian, Bulgarian, and Albanian Orthodox dioceses in America are under its administrative umbrella. Because of the cataclysmic events in Russia in 1917, the Russian Church was split by rival jurisdictions, each claiming a place in America. On one hand were the representatives of the Moscow Patriarch, dominated by the Soviet government. Another rival for parish loyalties has been the group led by the Russian Church in Exile (or the Synodal Church), the bishops who left Russia after the Russian Revolution, disowned the Soviet-dominated Moscow patriarchate, and set up their headquarters first in Europe and then in New York City. Many recent immigrants from Western Europe belong to the "Synodal" Church.

Despite their differences, however, all the churches join in 1994 in celebrating the bicentennial of Orthodoxy in America. They recognize that the first 110 years of the Orthodox mission was a period of unity, when all of the national churches were under one bishop and that only in the early 20th century did the divisions begin. The exhibit, *Heaven on Earth: Orthodox Treasures of Siberia and North America,* attempts to recreate that spirit of unity which once characterized this important institution by including liturgical art and objects from the Russian, Ukrainian, Greek, Serbian, Romanian, and Antiochian traditions.

An Orthodoxy Native to America

The American Orthodox Church began its life as a missionary outreach of the Russian Church in a far-off corner of the continent — in Russian America, the Alaska of today. Its emphasis in those early years, under the guidance of its first missionaries and its great Bishop Innocent (Veniaminov) was to bring Christianity, in its Orthodox expression, to the varied peoples of Alaska — Aleut, Eskimo, Tlingit, Athabascan, Russian, Serb. As Europeans made up the tiniest fraction of the Alaskan population throughout the era of Russian America (1741-1867), the work of the monks and priests was entirely evangelical — to preach, teach, and baptize, all the while traveling to incredibly remote islands and tundra villages. By the end of the Russian era, more than 10,000 Alaska Natives had been baptized into the Christian faith. Despite the passage of 127 years since the departure of the Russian government from Alaskan soil, the greatest majority of Alaskan Natives remain loyal to Orthodox Christianity.

In the process of evangelizing Alaska, the Russian missionaries brought the Christian message to the Alaskan people in their own languages, creating alphabets, primers, and translations of sacred works. They started schools which introduced not only Christianity but literacy in the local language, as well as training which equipped Natives for success in the new world introduced by the Russians. To a great degree, these missionaries succeeded in developing an Orthodoxy, native to the American continent, accommodating the ancient rituals

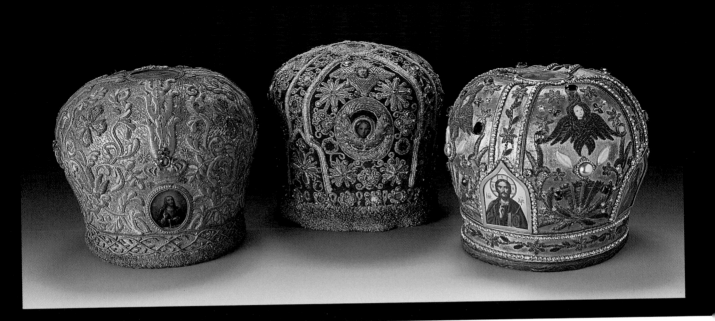

to new languages, new customs, and training Native Alaskans to serve their own communities as priests, layreaders, and teachers.

To understand the wellsprings of this form of evangelism one can look at the region from which its leaders came and where, in the beginning, the training of Native Alaskans took place — Siberia. Although the first missionary party of 1794 had come from western Russia, from monasteries at Valaamo and Konevetsk, the administration of Alaskan religious affairs came under the jurisdiction of the Bishop of Irkutsk. There was a seminary in Irkutsk and several important Alaskan figures received their training there, among them the Priest-Bishop John Veniaminov (Bishop and

Three Miters

Miter *(center)* — Russia, mid-19th century. Velvet, gold thread, colored glass, 20×18 cm. Irkutsk Regional Museum

Miter *(left)* — Mid-19th century. 73.8 cm. (circum.) St. Michael Cathedral, Sitka, Alaska

Miter *(right)* — Gold thread, rhinestones, satin, pearls, 20×21 cm. Provincial Museum of Alberta, Canada

Three splendid and unique miters representing Russia *(center)*, Russian America *(left)* and Canada *(right)*. The ones from St. Michael's *(left)* and the Irkutsk Museum *(center)* date from St. Innocent's time, the Canadian one was worn by Bishop Boris (Yakowkewich) of the Ukrainian Diocese of Edmonton in Canada (1965–1984). (Cat. 22, 84, 169)

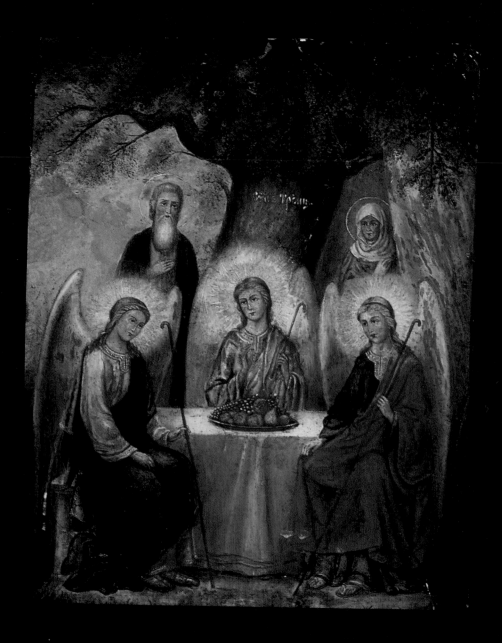

Icon: Old Testament Trinity — Jerusalem, 1908. Wood, paint, 31×24 cm. Orthodox Cathedral of the Holy Protection, New York City

By the order of the Orthodox Head of Mission in Jerusalem, this icon was written on a board cut from a portion of the Oak of Mamre under which Abraham talked with the Angels of the Lord. The icon of "The Hospitality of Abraham" was written on several boards, which were then given to the most eminent pilgrims (of the rank of bishop or above) to the Holy Land. (Cat. 183)

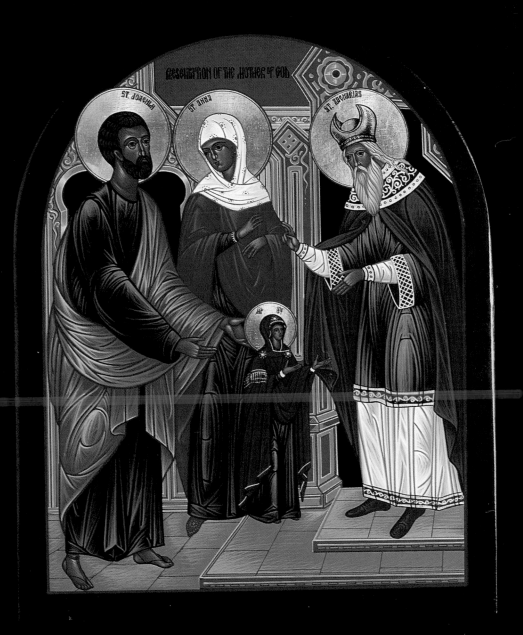

Icon: The Feast of the Entrance of the Virgin into the Temple — By the hand of Philip Zimmerman, 1989, Pennsylvania. Wood, acrylic, 20×15 cm. St. John of Damascus Sacred Art Academy, Antiochian Village, Ligonier, Pennsylvania

This contemporary icon describes one of the 12 feasts of the Church year. The Presentation of the Virgin in the Temple derives from the apocryphal Gospel of St. James, which tells of Mary having been dedicated to God by her parents. As a young girl she is brought by her parents Joachim and Anne to the temple, where she is greeted by the high priest and taken into the care of the Temple at Jerusalem. (Cat. 210)

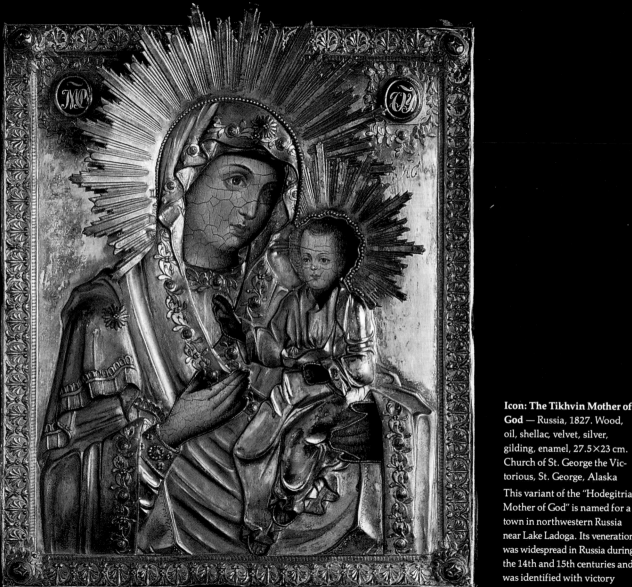

Icon: The Tikhvin Mother of God — Russia, 1827. Wood, oil, shellac, velvet, silver, gilding, enamel, 27.5×23 cm. Church of St. George the Victorious, St. George, Alaska

This variant of the "Hodegitria Mother of God" is named for a town in northwestern Russia near Lake Ladoga. Its veneration was widespread in Russia during the 14th and 15th centuries and was identified with victory

Saint Innocent), and Jacob Netsvetov, the Aleut who became the evangelizer to the Eskimos and who is to be canonized in 1994 as a saint. Furthermore, the headquarters of the Russian-American Company in its early years was in Irkutsk, and it was the home of the company's founder, Gregory Shelikhov. Furs from Russian America were received in Irkutsk and dispensed to China or to St. Petersburg. Supplies embarked for Kodiak and Sitka from Irkutsk, including many of the furnishings for the young churches of Alaska.

Siberian Orthodox Christianity was shaped largely by the character of its first bishop, canonized in 1804 as St. Innocent. Bishop Innocent (Kul'chitsky) was a man of noble birth, of legendary energy and humility. Sent in 1721 by Peter the Great to head an ecclesiastical mission to Peking, Innocent waited five years in Irkutsk for permission to enter China. There was no salary to support the bishop and his retinue of 12, so Bishop Innocent supported himself by giving lessons, painting icons, and sewing footwear. In 1727, he was ordered to give up the China mission, to establish a diocese in Siberia and open a cathedral in Irkutsk. Although now a person of stature, he continued to live as a simple monk, while also opening a school where Mongolian and Chinese, as well as Slavonic (the language of the Church services) were offered to boys of all social classes. The first missions to the Buryats, Tungus, and Yakut date from his five year tenure as Bishop of Irkutsk. The emphasis in Innocent's life on hard work, ingenuity, education, literacy, and mission was emulated by his equally

famous namesake, another Bishop Innocent (Veniaminov), the first bishop to serve in America.

Bishop Innocent (Veniaminov), who is revered today as St. Innocent Metropolitan of Moscow and Enlightener of the Aleuts, brought his Siberian roots to Alaska. He was born John Popov-Veniaminov in Siberia and entered the Irkutsk Seminary at the age of nine. His mentor for many years was Bishop Michael II. This talented administrator encouraged the young seminarian to develop skills which would stand him in good stead in the rude lands in which he would play out his destiny — including the art of clockmaking and carpentry. With the blessing of Bishop Michael, the young Priest John Veniaminov began his Alaskan career as a parish priest at Unalaska, a post for which he volunteered after being overcome (to his amazement) by a desire to serve in the remote mission field. He filled a void in Alaska, left by the deaths and departure of many of the original party of missionaries who had arrived in 1794 on Kodiak Island. Only a priest in Kodiak itself and the monk Herman on Spruce Island remained of the original ten. The Aleuts and Koniags had been baptized in great numbers by one of these missionaries, Makary, so that by 1800 most of the islanders were Christian. Still, the mission had lost its vigor and lacked leadership, until Priest John Veniaminov appeared in Unalaska in 1824. This indefatigable priest set to work traveling hundreds of miles by kayak to visit each Aleut community; he learned Aleut and developed an orthography and a primer. He translated scripture

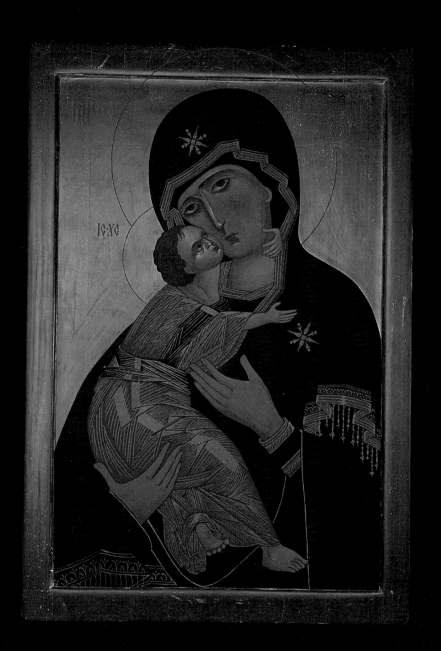

**Mother of God Umilenie
(Tenderness)** — By the hand of
Heiko Schlieper, 1985, Ottawa,
Ontario, Canada. Wood,
tempera, gold leaf, 64×42.8
cm. Provincial Museum of
Alberta, Canada
(Cat. 170)

into the Fox dialect and worked with a young Aleut associate, Jacob Netsvetov, to bring Scripture to the Atkans, whose language was slightly different. He built a church and a school at Unalaska and wrote a pioneering work on Aleut ethnography. In 1840, when he was tonsured a monk, he took the name of the great patron saint of Siberia, Innocent. It should come as no surprise that in all of the churches of the Aleutian region, in which the Priest John Veniaminov preached, there is a prominent icon of St. Innocent of Irkutsk — usually on the iconostas.

Unlike the famous Innocent of Irkutsk, who served only five years as bishop before his death, Innocent of Alaska was granted a long life and a varied field in which to exercise his many talents. He was consecrated bishop of a new diocese, separate from Irkutsk, in 1840 — the Diocese of Kamchatka, the Kurile and the Aleutian Islands. His episcopal see was the capital of Russian America, Sitka. From there he established new parishes in the Alaskan "bush" — at Nushagak, Russian Mission on the Yukon River, and Kenai — and strengthened the parishes at Kodiak and Sitka. He founded a seminary in Sitka which trained young Natives for church service, and a school which offered education to boys and girls on a par with schools in Siberia. He built a cathedral and an orphanage and turned to the difficult task of learning Tlingit and bringing Christianity to the people in their own language. Throughout his service in Sitka, he enjoyed the respect of his peers in the civil service of the Russian-American Company. In 1852, Bishop Innocent was raised to the rank of archbishop and given a new

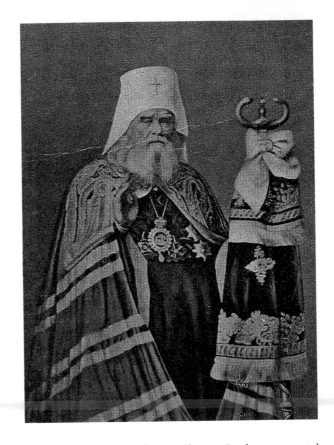

Metropolitan Innocent of Moscow, ca 1870. In 1824, Innocent, as the priest John (Ioann) Veniaminov established the church at Unalaska in the Aleutian Islands. He served as priest there until 1834, when he was transferred to Sitka, the capital of Russian America. In 1840, he took monastic vows and the name "Innocent," and was consecrated in Irkutsk as Bishop of Alaska. He later became Archbishop of Yakutsk and in 1868 was selected to head the Orthodox Church of Russia as Metropolitan of Moscow. In 1977 he was canonized as St. Innocent, Enlightener of the Aleuts and Apostle to America. Photograph courtesy Barbara Sweetland Smith.

archdiocese — with headquarters in Yakutsk, Siberia. From Yakutsk he continued his work of making Orthodox Christianity into a religion of the people, by translating Scripture and the Liturgy into Yakut. In 1868, he was elevated to the highest rank in the Orthodox Church of Russia, Metropolitan of Moscow, a position which he held until his death in 1879.

Siberia also left its mark on another Alaskan missionary — the evangelizer of the Eskimos, Jacob Netsvetov. Netsvetov was the first priest of Aleut descent. He was the son of the manager of the Russian-American Company post on Atka Island, and his Aleut wife. At his father's expense, he attended the seminary in Irkutsk and returned to Atka in 1828. He served there until 1844. In addition to his work with Veniaminov on adapting the Aleut translation for the Atkans, he founded a school. In 1843 his wife died and he requested that his old friend and colleague, now Bishop Innocent, allow him to take monastic vows and return to Siberia. Innocent knew the man's mettle and refused. Instead he gave him a vital task to perform. He sent him deep into the heart of Alaska, several hundred miles up the Yukon River to a small Russian trading post at Ikogmiut (Russian Mission). The missionary field which now opened up for this remarkable man was as large as the state of Texas, covering the immense Yukon-Kuskokwim basin. His journals reveal arduous and frequent visits by kayak and dog-team to scores of remote villages, the founding of chapels and training of laymen to sustain parish life. He opened a school and developed the first orthography and primer for the local Yup'ik dialects. In Alaska today, the legacy of Netsvetov is found in several dozen completely Orthodox villages along the Kuskokwim and Yukon Rivers which date their conversion to his years in the region and from which Orthodoxy draws the majority of its Native clergy. In 1994, during the bicentennial year of Orthodoxy, this missionary will be canonized as Saint Jacob.

By the time Russia sold Alaska to the United States, some 10,000 Native Americans were baptized in the Orthodox Christian Church. They worshiped in Aleut, Yup'ik, and Tlingit, as well as Church Slavonic. Although the Treaty of Purchase assured freedom of religion to all residents of Alaska, it was not immediately clear whether Orthodox clergy from Russia would be welcome in a foreign land. The answer came from Metropolitan Innocent himself. He issued a set of Instructions to Clergy in Alaska, which are a model of toleration and appreciation of indigenous cultures. He assumed the Alaskan mission would survive and founded a Foreign Missionary Society to assure that it would. Under his leadership schools were supported in more than a dozen Orthodox villages. Priests were sent to Alaska so that by 1906, there were 16 serving 15 churches and several chapels. A number of these were Native Alaskans.

The Americanization of Orthodoxy

The mission in Alaska replicated to a great degree the experience of the Orthodox Church in the Russian Empire. As new lands were added to the dominion of the Tsar, the Church and its missionaries followed. Just as the earliest missionaries to the Slavs developed Slavonic

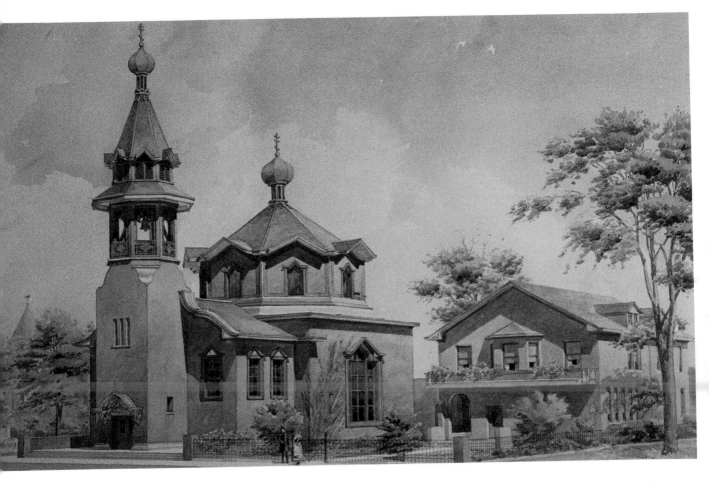

Holy Trinity Cathedral in Chicago. This substantial church was designed by the famous American architect Louis Sullivan in 1900 and is one of Chicago's most treasured landmarks. This watercolor painting of the cathedral is by Sullivan's own hand. Photograph courtesy Holy Trinity Cathedral, Chicago.

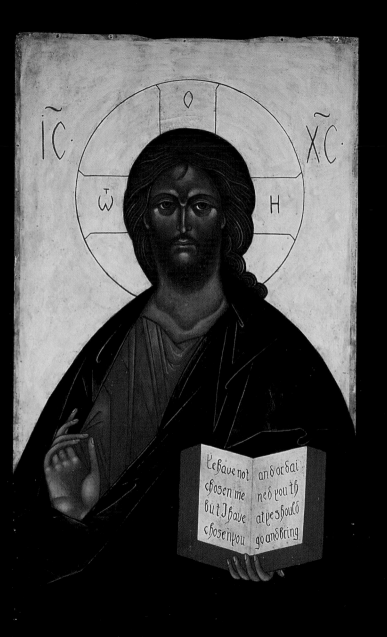

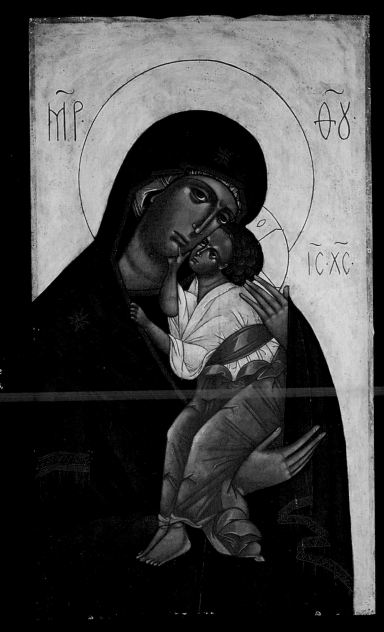

Icon: Christ the Savior

Icon: Mother of God and Christ — By the hand of Marie Elchaninova Struve, 1963, Paris, France. Wood, gesso, tempera, olipha, 108×63 cm. St. Vladimir's Orthodox Theological Seminary, New York

The French iconographer, Marie Elchaninova Struve wrote the icons of Christ the Savior and the Mother of God for the iconostas of the chapel at St. Vladimir's Orthodox Theological Seminary when it relocated from Manhattan to its present location near Yonkers, New York. They now hang in the nave of a new chapel. (Cat. 146, 147)

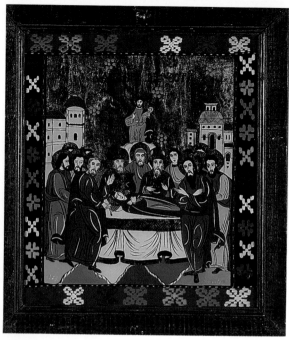

Icon: Dormition of the Mother of God — By the hand of Hieromonk Timotei Tohaneanu, 1970s, Sambata Monastery, Romania. Glass, paint, 49×40 cm. George Dobrea, Cleveland, Ohio

Written on glass, in the Romanian tradition, this icon is unusually rich, ornamented with gold. The scene is the death ("Dormition") of the Mother of God, with Christ receiving her soul in Heaven. The Apostles, two bishops and a monk gather in mourning around her bier. (Cat. 198)

as an adaptation of Greek to the Slavic language, the Russian missionaries were charged with the task of learning the new languages of Siberia and creating, wherever possible, an indigenous church. The Alaskan mission followed this pattern. But operating within a multi-cultural society such as America presented a different challenge for the Orthodox Church. The emphasis on mission shifted to provision of clergy, schools, and support for the hundreds of thousands of Orthodox immigrants to the United States — from many different lands.

Shortly after the U.S. purchased Alaska, the Orthodox bishop moved the episcopal see from Sitka to San Francisco. While Sitka had been a bustling town during the Russian era, it quickly slumped when the Americans came in. At the same time, San Francisco was in the midst of the Gold Rush. Among those seeking Eldorado were people of Russian, Serbian, Middle Eastern and Greek extraction. The Orthodox bishop of the newly named Diocese of the Aleutians and North America served a diverse community. He made occasional trips to Alaska but increasingly was concerned with the burgeoning Orthodox population in the states. The first parish was founded in San Francisco in 1868, when a priest arrived to serve a multi-ethnic community. On another American coastline, a large contingent of Greeks in Galveston, Texas, formed a parish. New Orleans followed in 1864, holding its services in Church Slavonic, Greek, and English.

As immigration swelled the population of the United States, and overflowed into Canada, the travels of the

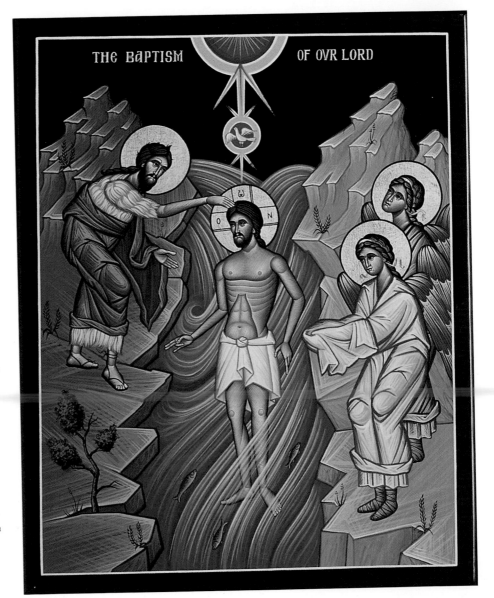

Icon: Baptism of Christ — By the hand of Kenneth Dowdy, 1990, Indiana. Wood, acrylic, 36×28 cm. Courtesy of the artist

Epiphany or "The Baptism of Christ" is one of the 12 feasts of the Christian calendar and follows closely after the Nativity of Christ (Christmas in the West). In this contemporary icon, Christ is shown with John the Baptist (also called "The Forerunner") and the angels who ministered to Him. (Cat. 241)

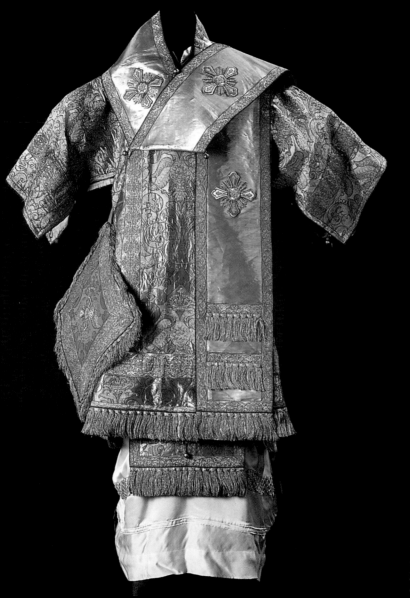

Bishop's Vestments

Sakkos, Epitrakhil, Omofor, Palitsa — Russia, 1895–96. Brocade, sequins, silk, metallic braid, gold thread, gilded silver buttons. Sakkos, 144×125 cm.; epitrakhil, 145×36 cm.; omofor, 4 m 7×24 cm.; palitsa, 36×36 cm. Irkutsk Regional Museum

This set is known as the "Coronation Robes." They were an Imperial gift to Archbishop Tikhon of Irkutsk who wore them to participate in the coronation of the last Russian Tsar, Nicholas II, in May 1896. (Cat. 12, 13, 15, 16)

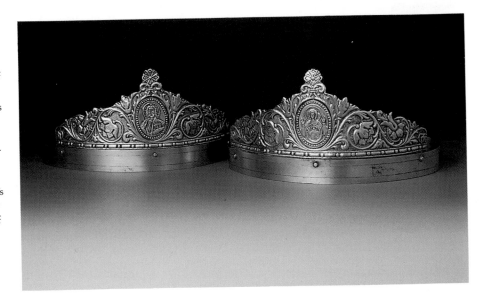

A Pair of Wedding Crowns —
Romania. Silver, 9×(diam.)
17.7 cm. Provincial Museum of
Alberta, Canada

Crowns are placed on the heads
of the bride and groom during
the Sacrament of Marriage.
The bride and groom, by wear-
ing the crowns symbolize the
indissoluble bond of Christ
and His Church. On the woman's
crown is an icon of the Mother
of God, on the man's an icon of
Christ. These crowns of silver
are typical of the Romanian
Orthodox tradition.
(Cat. 172, 173)

bishops of the Diocese of the Aleutians and North America grew more and more arduous. Gradually, auxiliary (or vicar) bishoprics were established — the first being in Alaska, and almost simultaneously, in New York. The Brooklyn vicariate was set up primarily to serve a large Middle Eastern population. Bishop Rafael (Hawaweeny), born in Damascus, Syria, was the first bishop actually consecrated in the U.S. These important steps were taken by Bishop Tikhon (Belavin). Bishop Tikhon came to North America in 1898 and served until 1907. His relatively short administration was pivotal and many of his decisions reflect the changing demography of America. He opened a training school for priests and a monastery; he commissioned the first translations of the Orthodox service books into English. His decision

in 1904 to move the episcopal see to New York City recognized that most of the new immigrants who entered the U.S. through Ellis Island would stay near the industrial East Coast. By the early 1900s, hundreds of thousands of refugees from the Austro-Hungarian Empire, from Russia, Greece, Serbia, and many other countries of southern Europe had flooded into the U.S. Many of these were unskilled workers ready to work at any price, and they were snapped up by the coal and steel barons of Pennsylvania, West Virginia, and Ohio. Numerous Orthodox communities also appeared around the industrial centers of Chicago and Cleveland.

One of the more interesting factors in the immigration boom of the 1880s and 1890s was the Greek Catholic,

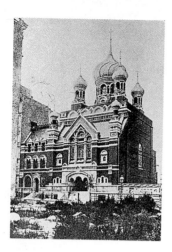

St. Nicholas Cathedral in New York City. This substantial church was commissioned by Bishop Tikhon in 1902 to facilitate his plan to move the headquarters of the Orthodox American diocese from San Francisco to New York. The move was completed in 1905. The rival Soviet-dominated "Living Church" was awarded ownership of the cathedral in 1925, one of the many trials faced by the diocese after the Russian Revolution. It remains in the hands of the Moscow Patriarchate. Photograph courtesy Archives, Orthodox Church in America.

or Uniate, Church. Between 1885 and 1908, more than 250,000 Slavic immigrants had crowded into the coal regions of Pennsylvania and West Virginia. Many of these were Greek Catholics, that is, they were Catholics who used the Orthodox, or Eastern, rite in their services. They also followed the Orthodox practice of a married clergy. The Roman Catholic leadership in the U.S. knew very little about the complicated politics of Eastern Europe which had produced this amalgam of religions and completely rejected the priests sent to America by the Catholic bishops of the Austro-Hungarian Empire. This left these impoverished, but needy communities, without priests. A dynamic leader, Father Alexis Toth, came to the U.S. in 1889 and sought to serve a parish in Minneapolis. After several years of futile efforts to gain acceptance by the Catholic hierarchy, he turned to the Orthodox bishop in San Francisco. The Orthodox were happy to welcome back to the fold the Uniates, whose ancestors had been Orthodox before the 17th century. The enormous size of this Greek Catholic population and the fact that many Uniates elected to follow Father Alexis, increased the number of non-Alaskan Orthodox almost five-fold and gave it a presence in many new cities, such as Minneapolis, Pittsburgh, Wilkes Barre, and in the numerous towns of the Mid-valley of Pennsylvania. In recognition of his tireless efforts to serve the many needs of this immigrant population, Father Alexis will be canonized a saint at St. Tikhon's Monastery in Pennsylvania in May 1994.

Two Panagias

Panagia *(left)* — 20.2×26.8 cm. Chancery, Orthodox Church in America

Panagia (Bicentennial) *(right)* — Liturgical Arts Workshop, Moscow Patriarchate, Sofrino, Russia, 1993. Gold plated with diamonds, Chancery, Orthodox Church in America

The panagia on the left was used by Metropolitan Theophilus (1934–1950). The one on the right was presented to Metropolitan Theodosius in 1993 by Patriarch Aleksy II of Russia when he visited the United States to inaugurate the 200th year of Russian Orthodoxy in North America. (Cat. 134, 144)

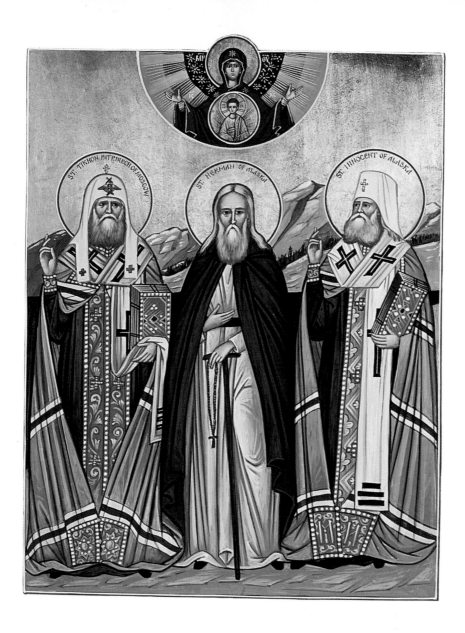

Icon: Three North American Saints — By the hand of Theodore Jurewicz, 1991, Erie, Pennsylvania. Wood, acrylic, gold leaf, 38×30 cm. St. Sergius Chapel, Chancery, Orthodox Church in America

The three North American saints are (left to right) Tikhon, Patriarch and Confessor of Moscow, Enlightener of North America; Herman of Alaska, Wonderworker; and Innocent Metropolitan of Moscow and Enlightener of the Aleuts. (Cat. 139)

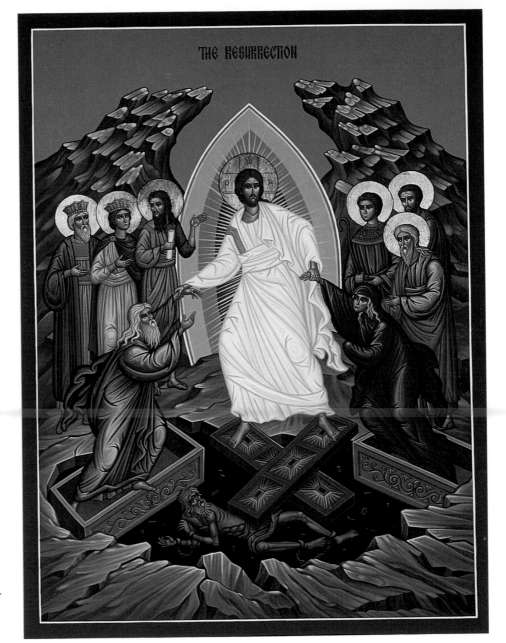

Icon: The Harrowing of Hell
— By the hand of Reverend Luke Dingman, 1992, California. Wood, acrylic, gold leaf, 61×45.7×1.3, cm. Courtesy of the artist

Orthodox observe all three days of Easter: Good Friday (the Crucifixion), Holy Saturday (Christ's Descent into Hell), and Pascha (Easter, the Resurrection). This scene reveals Christ breaking the gates of Hell and bringing forth Adam and Eve and the righteous men and women of the Old Testament. This icon, derived from a Byzantine tradition, was one of the earliest and most popular in the Russian iconographic tradition. (Cat. 162)

Antimins — Russia, 1746. Linen, 54×58 cm. Irkutsk Regional Museum

This antimins was presented to the Cathedral of the Epiphany (*Bogoiavlenskii*) in 1746 for the blessing of its opening. An antimins is essential to the celebration of Divine Liturgy and always bears the image of Christ's entombment. (Cat. 47)

Baptismal Box — By the hand of Deacon Victor Nick, Kwethluk, Alaska, 1987. Wood, 7.7×6.5×10.5 cm. St. Herman's Theological Seminary, Kodiak, Alaska

The work of an Eskimo artist, this is a wooden box used to carry the holy oil for use at baptisms. The scene is of the Baptism of Christ by John, with three angels in attendance. (Cat. 98)

Orthodox Unity is Shattered

Until 1913, the Orthodox bishop of the Aleutian Islands and America, appointed by the Holy Synod of Russia, was the titular head of all Orthodox in the U.S. and Canada, whether they be Greek, Romanian, Serbian, Syrian, Russian, Ukrainian or of any other national origin. The Russian Revolution changed everything in Russia and nearly swamped the Russian Orthodox in America. In addition to appointing all Church authorities, Russia had provided almost all finances for the American Church, as the Orthodox population in the U.S. and Alaska was extremely poor — either Native American or recent immigrants. All of this was cut off by the ascendance of the Soviet government. Communications also faltered. Archbishop Tikhon, formerly of America, had been elevated to Patriarch of Moscow in August 1917, in events which had nothing to do with the Bolshevik Revolution. This revival of the patriarchate, eliminated by Peter the Great in 1721, was a great show of independence for the Church of Russia, but the new voice was muted almost immediately. Patriarch Tikhon was placed under house arrest and efforts to communicate with him on vital issues affecting the American Church met with failure. Important decisions affecting the booming Orthodox population in America and the need for consecration of new priests and bishops, even liturgical supplies — all were jeopardized. As a result, several of the Orthodox national groups separated from the North American Diocese. The Serbs had left in 1913; the Greeks left in 1921; the Syrians (Antiochians) in 1925. At the same time, the American Church decided

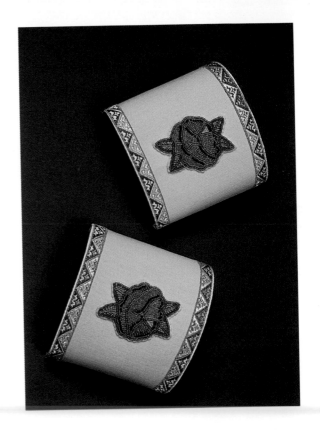

Cuffs — By the hand of Emma Marks, early 1980s, Juneau, Alaska. Polyester, wool, beads, 14×26 cm. Very Reverend Nicholas Molodyko-Harris, Anchorage, Alaska

The cuffs are part of a full set of vestments designed by the eminent Juneau, Alaska, Tlingit artist Emma Marks to be worn for the consecration of St. Innocent of Irkutsk Cathedral in Anchorage. The beading skillfully interweaves Christian and Tlingit motifs. (Cat. 158)

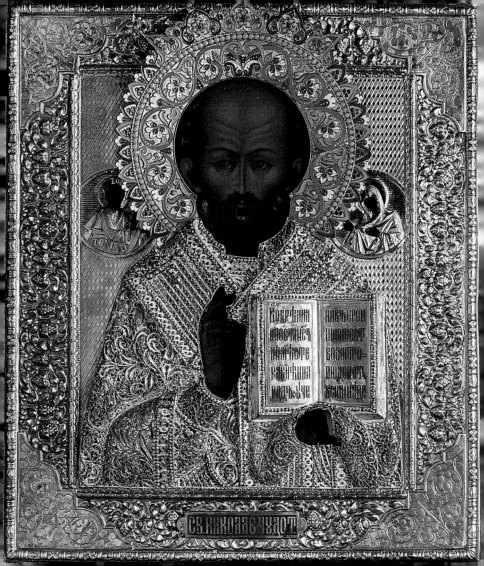

СВ. НИКОЛАЕ ЧУДОТ

Icon: St. Nicholas — Russia, 19th century. Wood, tempera, silver, enamel, 32.5×27.4 cm. St. Sergius Chapel, Chancery, Orthodox Church in America

St. Nicholas, the fourth century bishop of Myra in Asia Minor, is one of the most popular subjects of iconography. He is revered as a helper in time of trouble. (Cat. 133) *(Opposite)*

Icons: Archangels Michael and Gabriel — By the hand of Georgy Petukhov, 1850, Sitka, Alaska. Canvas, oil paint, wood frame, 70×54 cm. Holy Assumption of the Virgin Mary Orthodox Church, Kenai, Alaska

The companion icons of the two great Archangels were painted by an Aleut artist who had trained under Father John Veniaminov (St. Innocent) at Unalaska. The Kenai church inventory indicates they were acquired for the first church at Kenai, built in 1848. (Cat. 163/164)

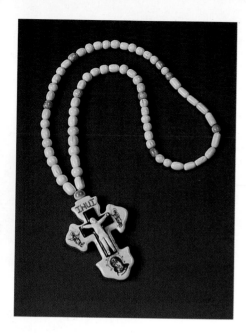

Pectoral Cross — By the hand of Patrick Pletnikoff, 1987, Alaska. Walrus ivory, gold, baleen, 10.7×7.8 cm. Very Reverend Nicolas Molodyko-Harris, Anchorage, Alaska

This cross by a talented Aleut artist was created for the priest of the Anchorage, Alaska cathedral. It reflects the skillful use of traditional Native materials in liturgical art. (Cat. 159)

it had to sever its own administrative connection with Russia, and at an All-America Council in 1924, declared its autonomy from the Russian Church. Its archbishop was to be the ruling bishop of a new entity, the Metropolia of North America and Canada — free to consecrate its own bishops. Metropolitan Platon, who had served earlier in the century as archbishop in America, was given the mantle of leadership — a daunting task, for the new metropolia was nearly bankrupt. Churches had been mortgaged in a desperate effort to survive but at the peril of Church properties. Metropolitan Platon steered the Church through this traumatic time and set the American Church on a sound, if modest, financial base.

The American Orthodox administration was faced not only with canonical and financial uncertainty but also with challenges to its very existence. The Soviet government created a rival church, the "Living Church," which claimed to inherit Patriarchal rights in America, that is, control of property and appointment of bishops. Although the Living Church has passed from the scene both in Russia and in America, the Patriarchal Church of Russia actively campaigned until 1970 to win parish loyalties away from the American metropolia.

The challenge from the Living and the Patriarchal Church was not, however, the only test of the new American metropolia. An even more significant challenge came from the Russian Church Abroad, also called the Synodal Church (as it is ruled by a Council — or "Synod" — of bishops). This Orthodox jurisdiction

began among the Russian bishops who fled Russia during and after the Revolution. They rejected the Patriarch as a tool of the Soviet government and declared themselves to be the true Church of Russia. In 1926, the Synodal Church announced its claim over properties and parishes in the United States, a claim which was vigorously rejected by Metropolitan Platon and his successors. Nonetheless, the Synodal Church continues to have influence in the United States, as it is the Church of many immigrants from Western Europe.

Although the American metropolia has been beset by challenges to its authority and loss of some national constituencies, it has made gains among other nationalities. Mention has been made of the Uniates. The Albanians and later the Romanian Orthodox chose to cast their lot with the American archdiocese. After the First World War, the United States provided the base for Albanian independence from the crumbling Ottoman Empire. And its principal leader was an Orthodox priest in Boston, Theophan (or Fan) Noli. Because of Noli's translations, the Albanians were able to celebrate in 1912, in Southbridge, Massachusetts, the Divine Liturgy for the first time ever in their native Albanian tongue, a language which had been suppressed for five hundred years. In 1919, Father Theophan was consecrated as vicar bishop for Boston, with principal responsibility for the Albanian Orthodox. Four years later, this distinguished cleric-scholar-diplomat was named Albania's first foreign minister and in 1924, he was elected premier. The volatile political situation in

ANTIMINS

Antimins literally means ''in place of an altar.'' An antimins is a four-cornered cloth made of linen or silk. In each of the four corners, or in the top part of the cloth, tiny pieces of holy relics are sewn into special, small pockets. [The relics in this exhibition's antimins were removed probably before they entered the Irkutsk museum, although the small pocket remains.] The image of the Entombment of Christ is represented in the central part of the cloth and images of the Evangelists are on each of the four corners. The first written account of antimins' use comes from the thirteenth century but oral tradition attests to their use in the first centuries of Christianity when worship services were often held on the tombs of martyrs. If a tomb with relics was not available, then the antimins with a tiny piece of the holy relics preserved in it could be used for an altar. When new churches were constructed, frequently there were not enough relics or if they were available, it was often difficult to convey them great distances. Thus, antimins with pieces of holy relics came into wide-spread use.

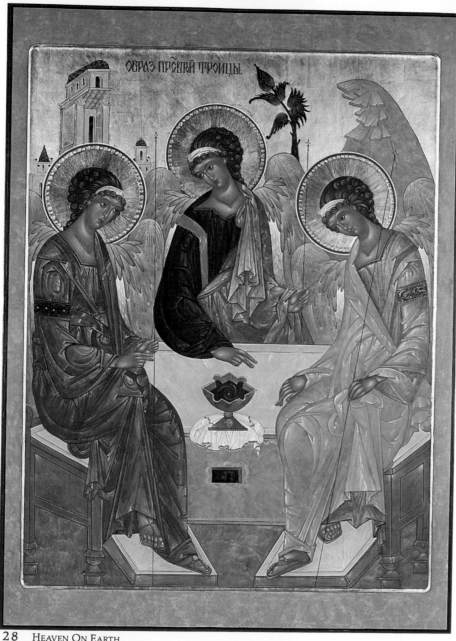

Icon: Old Testament Trinity
— By the hand of Vladislav
Andrejev, 1990s, New York.
Wood, gesso, tempera, gold
leaf, 76×56 cm. Courtesy of
the artist

This contemporary icon of the
Old Testament Trinity is in the
style of Andrei Rublev, the great
Russian iconographer of the
14th century, and shows only
the three angels, without Sarah
and Abraham. (Cat. 127)

the new nation spun him out of office within a year and
he returned to America in 1931 to take up leadership of
the American Albanian Orthodox Church. In 1971, the
Albanian Orthodox Church of America voted to join
the American metropolia, moving toward Theophan
Noli's dream of a single Orthodox jurisdiction in
America.

Another national church which joined the Metropolia
is the Romanian Orthodox Church. The Romanians are
the only Latin peoples within the Orthodox family.
Their language, Romanian, is derived from Latin, not
Slavonic. Most of the Romanian immigrants to the U.S.
came from Transylvania, which was in the 19th century
part of the Austro-Hungarian Empire. The first parish
was established in Saskatchewan in Canada in 1902 and
in the United States in 1904 in Cleveland. Romanians
also settled in and around Philadelphia, Chicago, and
St. Paul. In 1935, the Romanians in North America
received their first bishop, Policarp (Morusca), who
established the episcopal see in Detroit, Michigan.
He founded an official publication for the diocese and
traveled widely. In 1939, he went to Romania for a visit
and was trapped by World War II and the subsequent
communist regime, and was unable to return to America.
Thereafter the American Romanian Church was caught
up in many of the same battles for control from abroad
as the Russian Orthodox had been, with the government
in Bucharest attempting to assert authority over the
American parishes. Finally, in 1951 the American
Romanian Orthodox declared themselves independent
from the Patriarch in Bucharest. In 1960, the Romanian

Sulok — 20th century. Silk,
brocade, gold threads, 66×55.8
cm. Vestry of the Primate,
Orthodox Church in America

The embroidery on this sulok,
which is attached to the episcopal
staff or crozier, was transferred
from a vestment set belonging
to St. Tikhon. The set had been
used by him during his years as
Bishop of the Diocese of the
Aleutian Islands and North
America (1898–1907). It is
now worn by Metropolitan
Theodosius on special
occasions. (Cat. 132)

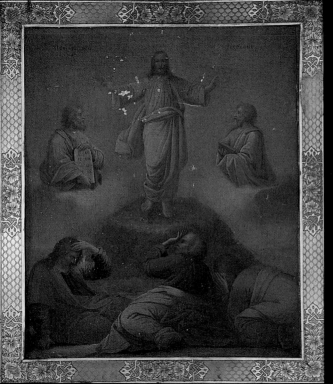

Icon: The Transfiguration — Moscow, Russia, 1868/1870. Wood, oil, velvet; riza: gilded silver, 27×23 cm. Church of the Holy Ascension, Unalaska, Alaska

On the reverse side, written in ink, is inscribed, "On the Island of Unalaska to the Church of the Transfiguration of Our Lord, 27 July, 1870, Moscow," with a signature of Metropolitan Innocent. This icon was sent by Metropolitan (Saint) Innocent for the consecration of the Holy Transfiguration Chapel in the village of Kashega, on Unalaska Island. (Cat. 89)

Episcopate requested and was granted admission to the Metropolia of North America.

The Orthodox Church in America

Despite the trials of the years after the break with Russia, the Orthodox in America succeeded in developing a strong indigenous core of leaders. As early as 1888, Bishop Vladimir had opened a pastoral school in San Francisco, for the training of readers and choir directors. Another school followed in Minneapolis 10 years later and became a seminary in 1905. The next year the Service Book for the Orthodox Church was published in English. Although the seminary, which had moved to New Jersey, closed in 1923, due to lack of funds, the distinguished St. Vladimir's Seminary opened in New York City 15 years later, in 1938. St. Vladimir's drew its dean and faculty from the most eminent theologians of Russia, whose families had emigrated to Europe. Among them were the Priests George Florovsky, Alexander Schmemann, and John Meyendorff whose writings and participation in ecumenical councils did much to acquaint the rest of the American Christian community with the Orthodox. In the same year, 1938, another seminary opened at St. Tikhon's Monastery in Pennsylvania. And in 1973, in Alaska, St. Herman's Pastoral School opened for the training of Alaska Native Orthodox leaders. It became a seminary in the following year, and by 1994, had graduated 17 Alaska Natives and ordained 19 to be deacons or priests.

The Americanization of Orthodoxy reached a peak in the 1970s when several events converged to reveal the

Panagia — By the hand of Very Rev. Vasily Epchook, Lower Kalskag, Alaska, 1990. Ivory, pigment, 10.2×7.8 cm. Bishop Gregory (Afonsky)

The late Very Rev. Vasily Epchook, an Eskimo artist, archpriest in a village on the Kuskokwim River in Alaska, carved this bishop's panagia with etched and painted images of the four saints of Alaska (Herman, Innocent, Juvenaly, and Peter the Aleut) and the Kazan Mother of God. (Cat. 85)

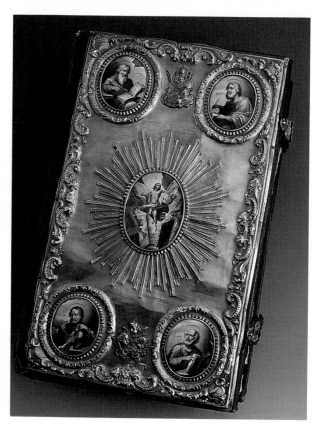

Gospel — Moscow, 1847.
Paper, wood, silver, enamel,
44.5×29.9×10 cm. Church of
the Holy Assumption of the
Virgin, Kenai, Alaska

This Gospel dates from the first
Orthodox Church at Kenai,
Alaska, built in 1848. The
enamel plaques are of the four
Evangelists in the corners and
the Resurrection of Christ in
the center. The Gospel weighs
13.5 pounds. (Cat. 166)

Church's new solidity and maturity as an American institution. The decade began auspiciously in 1970 with the glorification (or canonization) of the first American Orthodox saint, the monk Herman, a member of the original missionary party which had arrived in Kodiak in 1794. From the time of his death in 1837, he was revered as a saint by the local people of Kodiak. In 1970 an international gathering of Orthodox prelates assembled in Kodiak, Alaska, to proclaim the sanctity of St. Herman of Alaska, Wonder-worker of All America. His body was reinterred in the Church of the Holy Resurrection in Kodiak where today thousands of pilgrims travel each year to pray at his reliquary.

The proud proclamation of the first Orthodox saint of America was only one event in the path-breaking year of 1970. In April, the metropolia received recognition from Russia which it had sought for nearly 50 years. Although the American Orthodox diocese had declared itself self-governing, and not dependent on the Russian Church administration in 1924, the Russians had never accepted this *de facto* autonomy. In 1970, after years of delicate negotiations, the Russian Church agreed to a so-called "Tomos of Autocephaly," or Proclamation of Self-government. This act gave *de jure* recognition to the American metropolia as an independent Orthodox jurisdiction, "Independent and self-governing, with the right of electing her own primate and all her bishops, without confirmation or the right of veto . . . on the part of any other Church organization. . ." (From the Tomos). The Declaration noted with concern the jurisdictional divisions which had arisen within the Orthodox commu-

nity in America since 1917 and expressed the hope that such a canonical blessing by "the Mother Church" might allow the metropolia to serve once again as the home for all Orthodox within North America, to become in canonical parlance, the "local" Church for North America. At the All-America Great Council of the Orthodox Church in the fall of 1970, the assembled clergy and laity adopted a new name for the metropolia — the Orthodox Church in America (OCA), a name rich with the hope of those early leaders — Metropolitans Platon, Theophilus, and Leonty, and Bishop Fan Noli — who dreamed of restoring one Orthodox home in America.

It was appropriate that the individual selected by the Americans to receive the Tomos of Autocephaly from the Russians was the Bishop of Sitka and Alaska, Theodosius (Lazor). In his acceptance of the Tomos, Bishop Theodosius spoke both of the missionaries who came to Alaska from Russia in 1794, "bringing to the New World the holy Orthodox faith and the fullness of grace and salvation contained therein," and also of his own birth in America and his personal desire, like so many others, to be "fully Orthodox and fully American." Bishop Theodosius in 1977 became the first American-born Metropolitan of the Orthodox Church in America.

In this bicentennial year of 1994, the Orthodox in America still present a diverse family of faith. The Greek Orthodox number some two million and continue to be ruled by the Patriarch of Constantinople. Several hundred thousand Serbian Orthodox follow the lead of

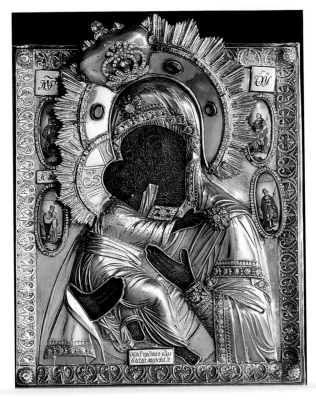

Icon: The Vladimir Mother of God — Russia, late 18th, early 19th century. Wood, tempera, shellac, silver, enamel, textile, 34×26.5 cm. Church of St. George the Victorious, St. George, Alaska

The Vladimir Mother of God is the most popular of the icons of "Loving Kindness" and is found in nearly every Orthodox church in the Aleutian/Pribilof region. The original is ancient and is in the Tretiakov Gallery in Moscow. (Cat. 112)

Royal Door Detail — By the
hand of Mihailo Jarinchika,
1933, Chicago, Illinois. Wood,
oil paint, gold leaf. Door dimen-
sion: 193×107×13.5 cm. Holy
Resurrection Serbian Orthodox
Cathedral, Chicago, Illinois

This detail of "Archangel Gabriel
of the Annunciation" is from
the intricately carved Royal
Doors of the iconostas in the
Serbian Orthodox Cathedral,
built in 1932, in Chicago.
(Cat. 176, 177)

(Opposite)
Deacon's Doors — By the
hand of Mihailo Jarinchika,
1933. Wood, oil paint,
180.3×152.5 cm. Holy
Resurrection Serbian Orthodox
Cathedral, Chicago, Illinois

The doors near the north and
south end of the iconostas were
carved and painted in a treat-
ment to resemble marble for
the new Serbian Orthodox
Cathedral built in 1932 in
Chicago. (Cat. 178, 179)

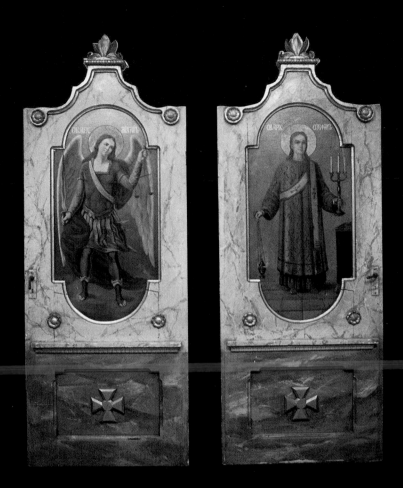

Belgrade. The Antiochian Church is small but growing, due to a large influx of evangelical Protestants in recent years. The Synodal Church continues to reject any and all acts of the Russian Church, including the granting of independence to the OCA and claims for itself authority over the American parishes. In Canada, the Ukrainian Orthodox Church is strong, particularly in western Canada. Thus, the ethnicity which has dominated Orthodoxy for the last 75 years is no closer to disappearing since the gift of autocephaly from Russia.

Despite the diversity which is so apparent, there are truly American elements in the Church today. There is one Orthodox Church, the OCA, which is completely free of foreign domination. When it proclaimed its own self-governance and freedom from Russia in 1924, it was at first as a matter of necessity, but increasingly as a burning desire to be "wholly American and wholly Orthodox." The language of choice for this Church and several other jurisdictions in their services is now predominately English, although other languages are used as the people themselves desire. The spirit of mission which brought 10 monks and novices across Siberia to Alaska 200 years ago is reviving within several Orthodox jurisdictions, as the Church increasingly recognizes the spiritual homelessness of many Americans. Given the nature of America, it probably will not be possible to create, in the foreseeable future, that single unified Orthodox Church of 200 years ago. Orthodox, however, pride themselves on thinking in terms of centuries, not decades, and are not ready to abandon the old dream of unity. In the meantime, they continue

to rely on the splendor and mystery of Orthodox liturgy, perpetuated in tradition and art to nourish the Church. Saints, from St. John Chrysostom to Jacob Netsvetov, iconographers whose names we do not know as well as today's masters of the ancient art, and Scripture itself remind the church to heed the call of Christ to his 12 disciples in the Gospel of Matthew (chapter 10) to go forth and preach "to the lost sheep."

Author

Barbara Sweetland Smith is the curator of "Heaven on Earth: Orthodox Treasures of Siberia and North America." She resides in Anchorage and is a historian and writer. In 1990 she curated "Russian America: The Forgotten Frontier," the award-winning exhibit organized by the Anchorage Museum of History and Art and the Washington State Historical Society, which toured for two years.

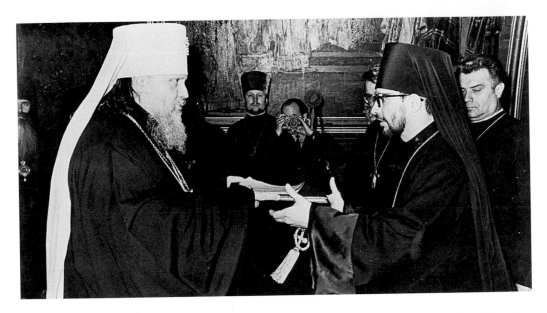

Bishop Policarp of the Romanian Orthodox Church during a pastoral visit. The bishop served as the first bishop from 1935-1939 of the growing Romanian community in the United States. He established his base in Detroit, Michigan, but served a wide constituency particularly in the Midwest. He was trapped in Romania by the outbreak of World War II and was unable to return to the United States. In 1960 the Romanian Episcopate was received into the Orthodox Church of America. Photograph courtesy Archives, Orthodox Church in America.

Bishop Theodosius (Lazor) of Sitka and Alaska *(right)* receives the Tomos of Autocephaly (Proclamation of Independence) from Metropolitan Pimen in Moscow in 1970. The acknowledgement by the Mother Russian Church of its independence had been sought by the American Church since 1924. Photograph courtesy Archives, Orthodox Church in America.

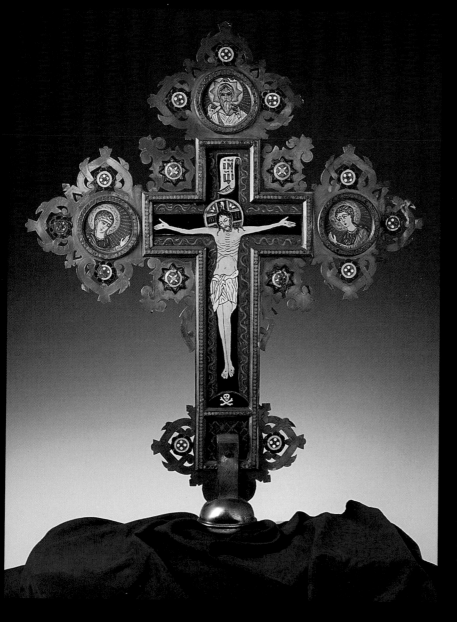

Processional Cross —
Belorus, early 19th century.
78×54.5×7 cm. Brass, enamel,
pigment, Orthodox Cathedral
of the Holy Protection, New
York City

This cross is one of the few pieces
that the congregation in New
York City was able to retain
from its old cathedral which, in
1925, was lost in a court case to
the Soviet-sponsored "Living
Church." (Cat. 182)

Suggested Readings

(Afonsky), Bishop Gregory. *A History of the Orthodox Church in Alaska (1794-1917)*. Kodiak: St. Herman's Theological Seminary Press, 1977.

(Afonsky), Bishop Gregory. *A History of the Orthodox Church in America, 1917-1934*. Kodiak, Alaska: St. Herman's Theological Seminary Press, forthcoming 1994.

Bolshakoff, Serge. *The Foreign Missions of the Russian Orthodox Church*. New York: The Macmillan Company, 1943.

Orthodox Church in America. *Orthodox America, 1794-1976*. Edited by Constance Tarasar. Syosset, New York: Department of History and Archives, 1975.

Smith, Barbara S. *Orthodoxy and Native Americans: the Alaska Mission*. Occasional Paper Number 1. Syosset, New York: Orthodox Church in America, Department of History and Archives, 1980.

Ware, Timothy (Bishop Kalistos). *The Orthodox Church*. Penguin Books, 1963.

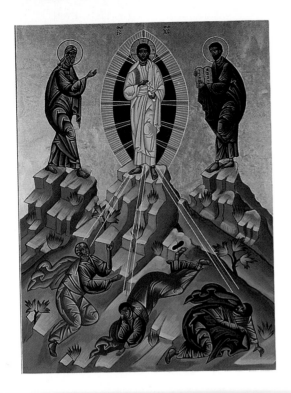

Icon: Transfiguration of Our Lord — By the hand of Dennis G. Bell, 1990, Ohio. Birch, acrylic, gold leaf, 76.2×50.8 cm. Courtesy of the artist

A contemporary icon for one of the 12 feasts of the Church year. The Transfiguration (Matthew 17) recalls the retreat of Christ to Mount Tabor, where he is transfigured with a Heavenly Light before the eyes of three disciples: Peter, James, and John, who see Christ speaking with the prophets Moses and Elijah. It was on this occasion that God, speaking through a cloud, revealed Christ's divinity to the disciples. (Cat. 212)

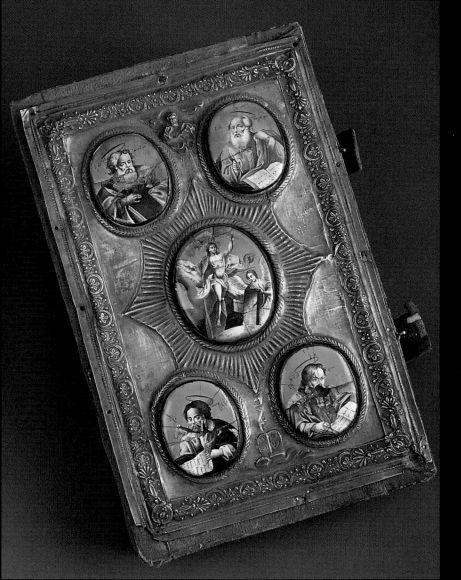

Aleut Gospel — St. Petersburg, Russia, 1840. Paper, embossed nickel/silver. 28×18×4.2 cm. Church of the Holy Ascension, Unalaska, Alaska

St. Innocent, when he served as missionary priest at Unalaska, developed the Aleut orthography and translated the Gospels into Aleut. This volume contains parallel texts in Church Slavonic and Aleut, and is a first edition. The Gospel is inscribed and annotated in the hand of St. Innocent. (Cat. 97)

LITURGY, THE ART OF ARTS

David J. Goa

The Meaning of the Divine Liturgy

O Lord, how manifold are thy works:
In wisdom hast thou made them all.
— Great Vespers

The opening chapters of the Bible make an astonishing declaration. Creation, the text sings, is the work of a loving hand, fashioned in divine delight for the purpose of enjoyment and loving communion. This declaration was as astonishing in the ancient Semitic world as it is in our own time. Creation is not the battleground of competing forces, good and evil. Nor is creation, as many in the ancient world and our own would have it, a field to struggle through in order to win some spiritual victory on the other side of life, to win a paradise offered only to those few souls who have the purity of character necessary to enter the Kingdom of God. Creation is not to be overcome in order to enter a reserved sacred world of which this one is only a shadow, a preparation. What the Biblical story proclaimed as the purpose and meaning of the gift of life, the Orthodox, more than most other Christian traditions, laid hold of and articulated. Thus,

life is fashioned by a loving Creator. When we dwell at the center of life, we dwell in the presence of the Kingdom of God, the place of communion, delight and wonder. The only real sin is "to miss the mark of life"; and the only choice human beings face — their freedom — is to dwell in life or to abandon what is real for that which steps outside of the creation, outside the world of loving communion.

While the Biblical hymns beautifully declare the glory and wonder of creation, most, if not all, human beings often experience the world as a place of struggle if not battle, and, all too often, as a place of agony and alienation. Yet, deep within the human spirit, and often in the story and song of human cultures, we hear the distant echoes of another way of knowing the world, echoes of an Edenic past or a paradisal future. Even modern poets sing of it:

For me the initial delight
is in the surprise of remembering something I didn't
know I knew. There is a glad recognition
of the long lost

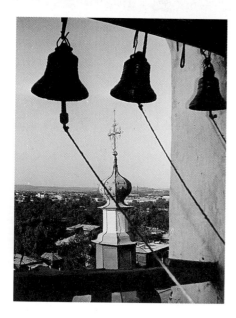

Bells have been called "angelic trumpets" and "hypnotic cacophony." They are an important part of an Orthodox service, calling the faithful, expressing the triumph of the Church and announcing principal acts of the service to those who cannot be present. A normal "set" will include nine bells; the largest weighing about 1550 pounds and the smallest about 20 pounds. This belfry overlooks the city of Irkutsk, Siberia. Photograph courtesy Vladimir E. Guliaev.

Small Plashchanitsa/Shroud of Christ — Irkutsk, late 19th century. Velvet, leather, sequins, gold and silver thread, silk, cardboard, 70×48 cm. Irkutsk Regional Museum

(Cat. 43) *(Opposite)*

What the American poet Robert Frost is "remembering" which brings him to a "glad recognition of the long lost" is also the work of the Orthodox Liturgy. The "art of arts" as the Liturgy has been called, is the "remembering," the "glad recognition" at the heart of human experience. Liturgy tutors the faithful in this art. The early Greek Fathers of the Church were very deliberate in their choice of the word "liturgy" for the work of the community of pilgrims who lived present to the Kingdom of God, at the heart of creation. The Greek word *leitourgia,* which they used to describe the work of the Church, signified a public duty, a public work. Just as those who teach the young or those hunters who provide food for their community in Alaskan villages are engaged in work for the whole of society, so the Church in its central act is doing a work on behalf of all creation. Liturgy is not private prayer, not the personal outpouring of the longings of the human soul, although personal prayer and longing are called forth in Liturgy. Liturgy is not a sacred duty performed to ensure the soul's salvation or to mark the faithfulness of the community of believers, and win them an eternal reward beyond the frame of this life. Rather, as the title of this exhibition suggests, it is a recognition of *Heaven on Earth,* of life as communing love. Liturgy is the art of coming anew into the presence of the Creator and the art of restoring creation to herself. Orthodoxy, in its liturgical practice, is a cosmic religion, remembering creation as the grace-filled world so easily forgotten, the playground of God's delight. Liturgy calls the faithful out of alienation to a life of loving communion. Liturgy is the art of remembering.

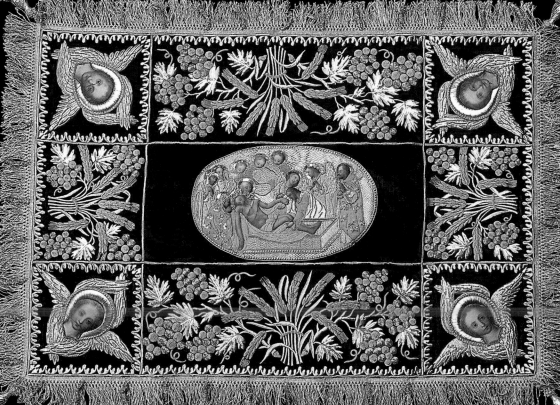

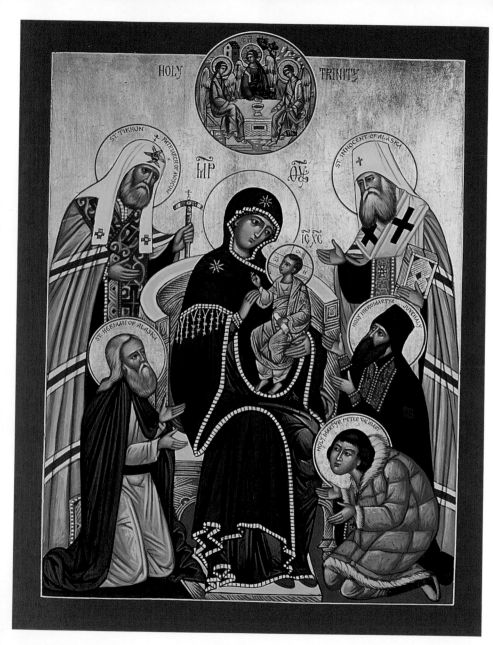

Icon: Bicentennial Icon — By the hand of Theodore Jurewicz, 1992, Erie, Pennsylvania. Wood, acrylic, gold leaf, 38×30 cm. St. Sergius Chapel, Chancery, Orthodox Church in America

The Mother of God Enthroned holding the infant Jesus is surrounded by the North American saints: Herman, Tikhon, Innocent, and the martyrs Juvenaly and Peter the Aleut. (Cat. 141)

What is remembered through this art of arts is not a past state or a vision of the future. What is remembered in the Divine Liturgy is the Presence through which the past and the future come to have meaning in this life, now. This life and this world are what the Bible and the Orthodox tradition call the Presence of the Kingdom. "Heaven on Earth" is in no sense a nostalgic dream or a utopian vision. On the contrary, the living tradition of Orthodoxy understands the Kingdom of God — the life of loving communion — as the fullness of creation. Scripture and the mothers and fathers of Orthodox tradition tell us this world was made in joy and for joy.

The Journey of the Liturgy

For, behold, I bring you good tidings of great joy.
— The Gospel of Luke

The Liturgy of Saint John Chrysostom was first chanted on the shores of Alaska two hundred years ago. The first Russian monks (from the Valaamo Monastery led by Archimandrite Ioasaph in September 1794) and the remarkable spiritual lineage which followed (men such as the martyrs Peter the Aleut and Hieromonk Juvenaly, the righteous father Herman, the Aleut elder Smirennikov, the heirarchs Innocent, Nicholas and Platon, and the holy great-martyr and enlightener Tikhon, Russian and Aleut alike) were proclaiming the joy that flows from the recovery of the sanctity of creation.

Liturgy is the art of arts because it both models and makes present the joy that is the center and purpose of creation. It does this by placing the gift of creation back into a

Icon: St. Nicholas, the Miracle Worker — Russia, 19th century. Wood, oil, gold leaf, 27×23 cm. Irkutsk Regional Museum
(Cat. 67)

relationship with God, who gives and sustains life and, as the lover of the world, who calls life back when it falls into darkness and death. Liturgy is not the enunciation of a theological position, although it has a highly articulated theology. Rather, it is the prayer of the Orthodox Church, and the prayer is a journey for the faithful back into communion "with the long lost," with their deepest self, with creation and the Divine. It is that journey into communion and the joy of a sanctified creation that we see in the shape of the Liturgy.

The liturgical journey — the journey to life itself as the tradition teaches — is characterized by offering, thanksgiving, communion and adoration. The path of the journey is a spiral, not a straight line, and in the Liturgy offering, thanksgiving, communion, and adoration are encountered more than once. Offering includes holding up both that which diminishes creation and the joy and wonder of human experience. We simply cannot recover the joy of a life of communion without bringing those experiences which fracture one's relationships into consciousness, recognizing and confessing the divisions they have created in our life, and asking to be forgiven for the failure to love aright. The offering of confession shaped by the Liturgy calls forth from the faithful recognition of how they have missed the mark of life, their failure to live and act in loving communion. The acts which diminish life are uncovered and held up to the Divine for forgiveness and healing. The fractured life of the world in which all human beings live is also brought forward from the darkness of pride and self-interest. Confession, an initial step on the path of the art of arts,

is the primary act of making conscious. Its goal is clarity from which healing is possible. The faithful also offer the joys and gifts of life holding them up in a moment of contemplation, recognition, and remembrance of "something I didn't know I knew." Even the joys and gifts of life, even that which is loved, can grow remote when we fail to offer them to "the giver of all good things." In offering, wonder is recovered, joy restored.

A curiosity of the human spirit that both spiritual masters and modern psychology have pointed out is that when acts of confession — acts of consciousness — are real, human beings are often filled with thanksgiving and gripped by the sheer wonder of creation. It is here that the Liturgy, both in its words and actions, gloriously expresses the gratitude which flows from the heart moved by glimpsing again the wonder of being. The priest and the gathered faithful chant:

Bless the Lord, O my soul; blessed art Thou, O Lord.
Bless the Lord, O my soul,
and all that is within me bless His holy name.
Bless the Lord, O my soul,
and forget not all that He has done for thee:
Who is gracious unto all thine iniquities,
Who healeth all thine infirmities,
Who redeemeth thy life from corruption,
Who crowneth thee with mercy and compassion,
Who fulfilleth thy desire with good things;
thy youth shall be renewed as the eagle's.

Bless the Lord, all ye His works,
in every place of His dominion,
Bless the Lord, O my soul.

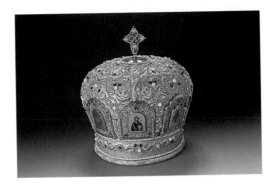

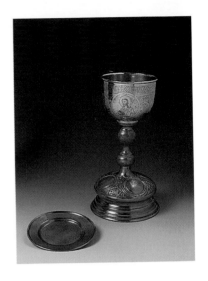

The sense and act of thanksgiving reach a crescendo with the Eucharist. The Eucharist is the very heart of the Liturgy, and at its center is communion. The Greek origin of the word "eucharist" means thanksgiving, and for Orthodox Christians its supreme act is the offering to the faithful of the gifts of bread and wine. Built on the blessings over the bread and the wine that welcomed the Sabbath in the home of Jesus, as they do to this day in Jewish homes, this ancient Christian prayer speaks of the transformation of the most common gifts of creation, bread and wine, into the body and blood of Christ. The Christian revelation about the incarnation of God in Christ speaks of both the love of God and the sanctity of creation. Creation is God's and the human being is called to be as Christ. Within the Gospel texts

Miter — The Arts Production Enterprise of the Moscow Patriarchate, 1991, Sofrino, Russia, 25.5×(diam.) 23.5 cm. Vestry, Primate of the Orthodox Church in America

This miter was presented to His Beatitude Metropolitan Theodosius by His Holiness Patriarch Aleksy II of Moscow and All Russia during his first pastoral visit to America in November 1991. The icons are replicas of those on a pre-Revolutionary miter now in a museum in the Kremlin in Moscow. (Cat. 145)

Chalice — Russia, 1906. Brass, silver, gilding, 30×(diam.) 15.5 cm.

Paten — Brass. 13.5×13.5 cm. Church of the Advent (Episcopal), San Francisco, California

These two utensils for the Holy Eucharist were given as a gift by Archbishop (Saint) Tikhon to the Episcopal Church of the Advent of Our Lord in San Francisco which lost everything in the Great Earthquake of 1906. Archbishop Tikhon had served in San Francisco until he moved his see to New York in 1904, and had been friends with the priest of the Episcopal Church. (Cat. 214/215)

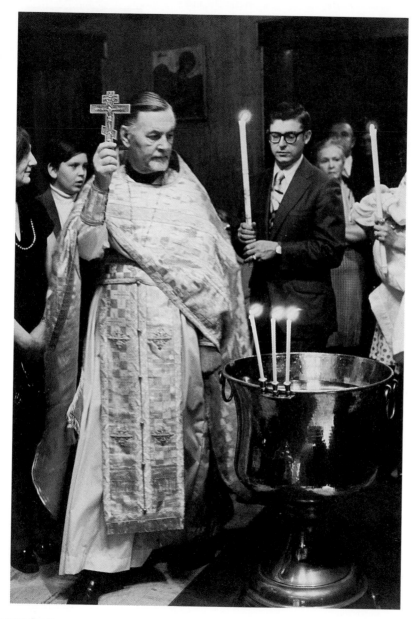

The bread of the Holy Eucharist, the *prosphora,* is placed on the paten and covered by the star, or asterisk, preparatory to Divine Liturgy. During the service a portion is cut out and placed in the chalice with the wine to be served during Communion. Photograph courtesy St. Vladimir's Orthodox Theological Seminary.

The baptismal font has three candles on its rim, symbolizing the Holy Trinity. The priest, holding a cross, leads the newly baptized child around the baptismal water. The godparents of the child hold candles symbolizing the new life in Christ, "the light of the world." The child has been immersed three times in the water symbolizing death and resurrection with Christ, in the name of the Father, Son, and Holy Spirit. Photograph courtesy St. Vladimir's Orthodox Theological Seminary.

we find Jesus referred to over and over again as the Second Adam and as the Son of Man. The Incarnation unveils the mystery of the human nature in its fullness as God created it, as well as the mystery of Divine love. This insight was captured by the Church Fathers in a refrain that runs through the Orthodox theological tradition: "God has become man so that man may become God." What sort of god, what sort of spiritual being does this suggest that human beings are? We get a glimpse of the answer in another Orthodox saying first articulated by Saint John Chrysostom, the Church Father who gave the form to the Divine Liturgy used in Alaska to this day: "You may be the only Christ the stranger ever meets."

Communion is the culmination of the Eucharistic prayer at the heart of the Liturgy because Orthodoxy is proclaiming communion as the character of human life. Creation is, in its true nature, the life of communion free of alienation and death. Just as communion was the character of life in the Garden of Eden in Genesis, so it is the character of the Presence of the Kingdom of God. Human beings are called, not out of their nature, but to the fulfillment of their nature in acts of communing love. Communing love is the Divine nature, "the Christ likeness" at the heart of the recovery of our humanity.

All that we know of God, we know through Christ. To be deified, to experience *theosis,* is not to become powerful as power is normally understood. Christianity is curious in this way. Its understanding of the Divine is rooted in the life and teaching of Jesus and as such it has nothing

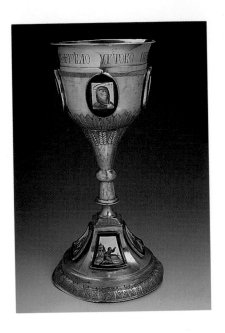

Chalice — Russia, 1836. Gilded silver, 8 enamel miniatures, 29 × (diam.) 15 cm. St. Michael Cathedral, Sitka, Alaska

Father John Veniaminov (Bishop and St. Innocent) used this chalice for the first services in the new chapel at Fort Ross, the Russian outpost in Northern California. (Cat. 83)

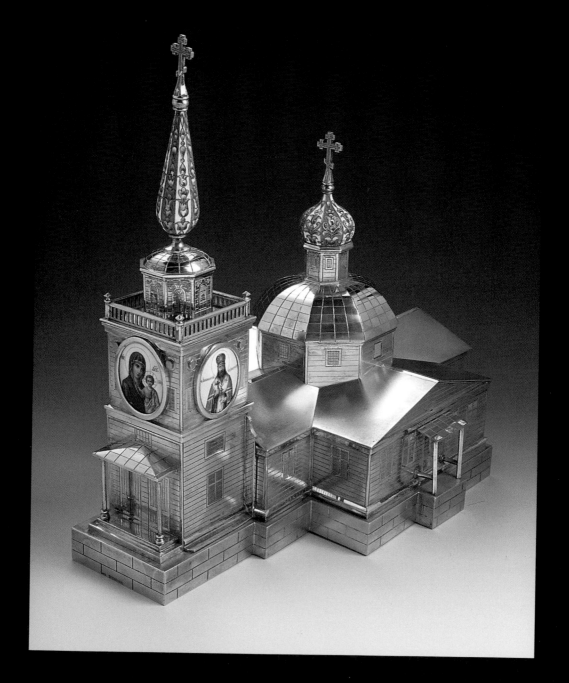

to do with power and achievement. Glimpsing the wonder of creation, and remembering the "long lost," the communing love that is central to life, engenders a profound compassion in the faithful which leads to a life of service to the world. The Christian is called in co-suffering love to restore communion where there is alienation, to restore life where there is only darkness and death. Bringing about communion midst the terrors and disappointments of history is the vocation of those who receive that communion which places them in the Presence of the Kingdom of God.

The adoration which flows from the mind and heart of the faithful to the Creator of all life is given its highest

Tabernacle — O. Kurliukov, 1901–1906, Moscow, Russia. Silver, gilding, cloisonne enamel, porcelain, 33×9×14 cm. St. Michael Cathedral, Sitka, Alaska

This exceptional vessel, in the shape of St. Michael Cathedral in Sitka, was used on the altar of the Sitka Cathedral to hold the Reserved Sacraments. It was commissioned in 1901 by the Russian and Indian Brotherhoods of the Cathedral and completed in Russia in 1906
(Cat. 79) *(Opposite)*

After a 70-year absence, the body of St. Innocent (Kul'chitsky) of Irkutsk is returned home. On September 2, 1990, the Orthodox faithful led by Bishop Vadim of Irkutsk and Nerchinsk celebrate at the Church of the Holy Sign *(Znamensky Kafedral'ny Sobor)* in Irkutsk. Photograph courtesy Vladimir E. Guliaev.

expression in the Second Antiphon, Psalm 145, of the Divine Liturgy:

> *Praise the Lord, O my soul,*
> *I will praise the Lord in my life,*
> *I will chant unto my God for as long as I have my being.*

Adoration, as the historian of religion Mircea Eliade has pointed out, is the essential act and feeling of the human nature.

The Liturgy and the Temple

When we examine the words and actions of the Liturgy we see a ritual journey shaped around the entrance into the Presence of the Kingdom of God where all things are united in love through forgiveness. As a spiritual disci-

Icon: St. Andrew, the First Called — 19th century. Wood, oil, gesso, shellac, 58×41 cm. Church of the Holy Ascension, Unalaska

This icon of the first apostle is in the Church of the Holy Ascension in Unalaska, Alaska. It bears evidence of Aleut origin. Note the Aleutian-style volcano in the right background. (Cat. 88)

(Following Page)
St. Michael Cathedral in Sitka, Alaska, has been a popular subject for modelling. Here, members of the St. Nicholas Brotherhood and their families gather around an exact-scale model of the city's chief landmark. The model was built in 1909 for a Smithsonian exhibition. The carpenter was a local shipwright, Vasily Shergin, a parishioner, who is seated at the right holding the carpenter's square. The cathedral itself was designed and in large part built by Bishop Innocent (Veniaminov), St. Innocent in 1844-48. Photograph courtesy Alaska State Library.

pline the Liturgy cultivates the priestly dimension of human nature, the vocation of men and women alike for blessing and healing all that they encounter in their life in the world. The environment of the Orthodox Church, its purpose and function as a temple of the Presence of the Kingdom of God, and all the actions of the Liturgy are leading the faithful back into creation as it essentially is.

When we enter the Orthodox Church we are entering a microcosm of the Kingdom of God. In this sense the Orthodox Church is not simply a meeting house, a house of prayer, a place for the reading of scripture and teaching through sermon as the church is in most Protestant traditions. Rather, the Orthodox Church is an iconic pattern of the Kingdom of God, a place where all those men and women whose lives were grace-filled are present. The icons that fill the Church are both the presence of the transfigured lives of the saints and reminders that all human beings were created in the "image and likeness of God," in and for communing love. Icons also make clear to the faithful that they are not alone in the world. Instead they share in the life of the Kingdom, "the Kingdom that has no end," precisely because it is a Kingdom which calls life to itself and banishes that which diminishes life. The symbolic shape of the Orthodox temple — the nave or body of the church and the sanctuary bridged by the iconostas — speaks of the Presence of the Kingdom of God, of creation restored to herself when lived in love, and of the dynamic movement of life toward the Fullness of the Kingdom of God, open to the future. That is why the action of the Liturgy

BRASS CASTWORK

From the early days in Rus', fine brass castwork was the most wide-spread form of applied arts because it could be produced by mass production rather than individually modelled. Crafted brass objects were convenient, simple in their technological preparation and provided an inexpensive method of popularizing the Christian saints. In 1722, after the Holy Synod issued a decree prohibiting brass castwork in the official Russian Orthodox Church, Old Believer brass castwork became the bearer of this ancient Russian art tradition. There are different styles of brass castwork. Pomorskii styles differ from Central Russian, particularly in the crosses. On the Central Russian pieces The Lord of Hosts and the Holy Spirit, in the form of a dove, were depicted and the sign "IUKI" (Jesus of Nazareth King of the Jews) appeared. The reverse side was either partially or completely filled by an inscription of praise to the Cross. A Pomorskii cross always had the image of "Christ made without hands" on the upper end of the cross and floral ornamentation on the back side. Pilate's inscription (Jesus of Nazareth King of the Jews) was prohibited among the Old Believers of the Pomorskii school and thus, the characters "IC" or "XC" appeared.

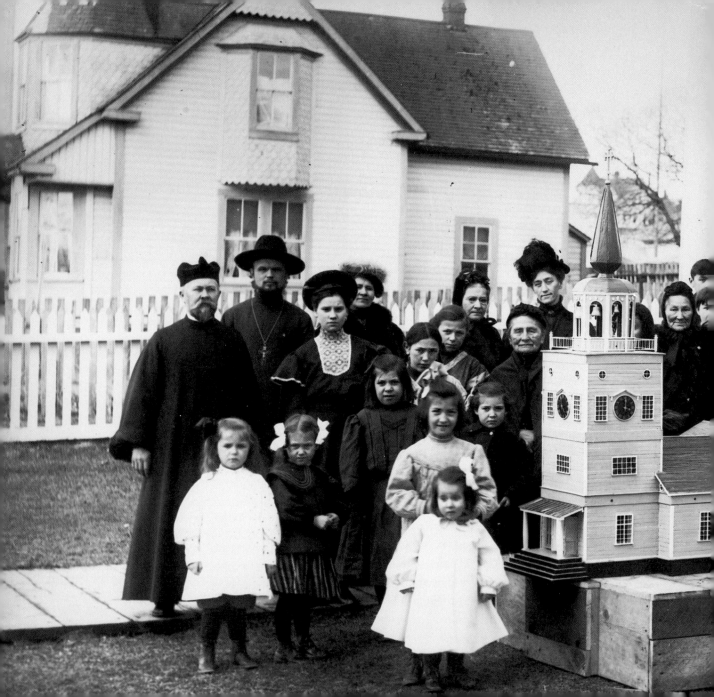

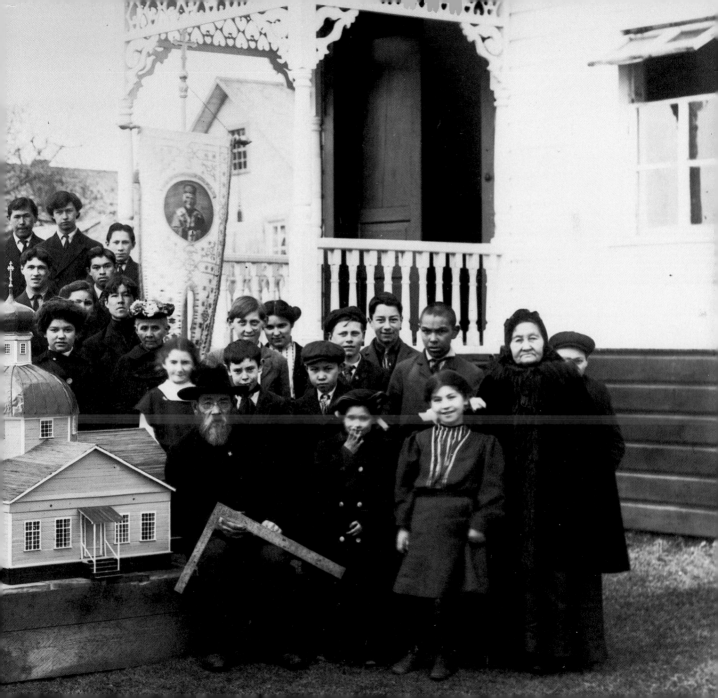

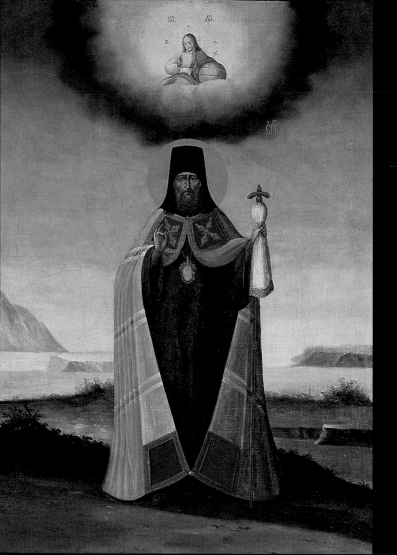

Icon: St. Innocent of Irkutsk
— Alaska (?) late 19th century.
Canvas, oil paint, 92.1×64.8 cm
Chapel of St. Alexander Nevsky,
Akutan, Alaska

Although the iconographer
is unknown, this icon bears
evidence of Aleut artistry. In
particular, the treeless land-
scape is typical of the Aleutian
Islands and not of Irkutsk. The
canvas is unusually rough. The
icon received conservation treat-
ment in 1993. (Cat. 86)

is a movement between the nave and the sanctuary, the world of Presence and of Fullness coming to be. The iconostas is not a barrier but a bridge articulating the dynamism which characterizes life when it is lived openly in friendship with God. Priest and deacon move through the doors in the iconostas bringing the gift of God's Word — the Gospel Book — and the gifts of bread and wine which unite the present world in which the faithful live with the coming Fullness of the Kingdom of God.

Along with being a *theophany* — a showing forth of the Kingdom of God — the Divine Liturgy is also a spiritual discipline, a path-way to holiness. When the faithful enter the church they greet the icons with the kiss of friendship and with prayer. This greeting is a recognition of the "image and likeness of God" in the grace-filled life of the saint and an act of identifying with all those who dwell in the Kingdom of God. Just as the saints struggled to let go of those illusions which diminish life, so the faithful discipline their lives in the struggle to recognize more deeply the wonder of creation and respond to the whole human family in compassion and love. The spiritual disciplines — prayer and praise, confession, veneration of icons, listening to the Word of God, and opening oneself to the gifts of the Eucharist — are all part of the journey to the recovery of "the long lost," recognition that human nature is only finally itself as "image and likeness of God." Recognizing other human beings as created in the image and likeness of God calls forth in the faithful the response of love and the desire for friendship.

Church of St. George the Victorious Holy Martyr on the Pribilof Islands of St. George, in 1986. This church was built in 1936. The first chapel on the wind-swept treeless island in the Bering Sea was built in 1833. Its congregation is almost entirely Aleut. Photograph courtesy the National Park Service.

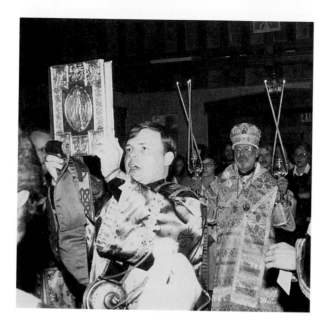

Before reading from Scripture, a deacon carries the Gospel leading a fully vested bishop from his place in the midst of the congregation to his place before the altar table. The bishop holds the pair of candles which represent on one hand the dual nature of Christ (the dikiri) and on the other the three persons of the Trinity (trikiri). He wears the bishop's miter or crown. Photograph courtesy St. Vladimir's Orthodox Theological Seminary.

It is this response of co-suffering love that shapes the Orthodox tradition's understanding of the human vocation. The icon of the Theotokos, the image of Mary the birth-giver of God and the Christ child, is, at least on one level, the icon of the human vocation. This is the image of what all human beings are called to do in their life in the world: to be birth-givers of divine love. It is for this reason that the Theotokos or Mother of God is so prominent in the iconography and so central in the liturgical prayer of the Church. In the classical Byzantine Orthodox Church the Theotokos fills the apse in the sanctuary and, in all Orthodox churches, even the most humble, her icon graces the iconostasis along with the icon of Christ, and one side of the church is dedicated to her. Throughout virtually all the Orthodox liturgies the Theotokos is invoked to assist the faithful on the path to opening themselves to the Divine, a path of which she is the exemplar. The Theotokos calls the faithful to bring forth Divine love in the midst of the vagaries and terrors of history. She calls them to become workers in the wonder of life. Orthodoxy, particularly the Russian tradition, is crystal clear in its sense that all human beings are capable of being wonder-workers. To identify with the holy Theotokos is to recover that dimension of our own nature through which Divine love flows. It is in such actions that the experiences of life are revealed as the often misconstrued pangs of that which is life-giving, struggling to be born.

The Divine Liturgy is showing the faithful what creation is intended to be: the place of the Kingdom, the place of communion and joy. Liturgy invites the faithful to disci-

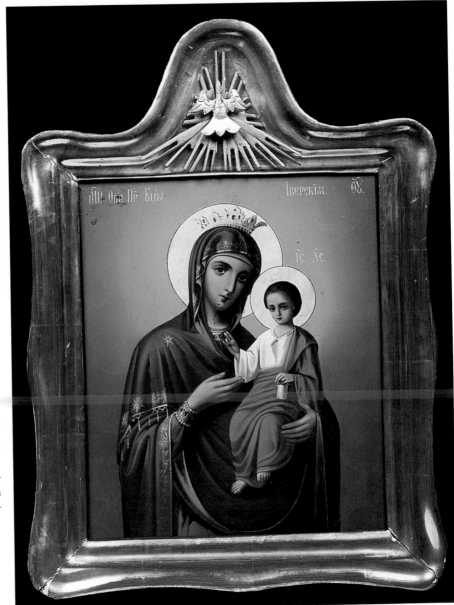

Icon: Iverskaya Mother of God — Smolensk, Russia, 1854. Wood, paint, gold leaf; frame: wood, 50.5×37 cm. St. Michael Cathedral, Sitka, Alaska

This wooden panel had another icon on it and when it was taken to be cleaned, this lovely rendering of "The Iverskaya Mother of God" was uncovered. The frame dates from the early 1800s. (Cat. 72)

The chalice containing the bread and wine of the Holy Communion, or Eucharist, is held aloft by the bishop as he receives communion. Around the rim of the chalice are the words, "Receive the body of Christ; taste the fountain of immortality." Baptized children and adults who have fasted and confessed are invited to partake of the Holy Mysteries. Photograph courtesy St. Vladimir's Orthodox Theological Seminary.

pline their lives in service to the restoration of creation and the recovery of the fullness of the human nature in a life of loving communion. Liturgy is the art of arts precisely because it is the art of restoring human beings to their nature as the "image of God" and to a life which is increasingly one of co-suffering love moving towards the "likeness of God" which is glimpsed in the Christ.

Author

David Goa is the curator of Folklife at the Provincial Museum of Alberta, Canada and Adjunct Professor of Religious Studies at the University of Alberta. In 1986 he developed the museum exhibit, "Seasons of Celebration: Ritual in Eastern Christian Culture," which toured Canada for four years.

Suggested Readings

Lossky, Vladimir. *Orthodox Theology: An Introduction.* Crestwood, NY: St. Vladimir's Seminary Press, 1978.

Mantzaridis, Georgios I. *The Deification of Man.* Crestwood, NY: St. Vladimir's Seminary Press, 1984.

Puhalo, Lazar. *Innokenty of Alaska: The Life of Saint Innocent of Alaska.* Chilliwack, British Columbia: Synaxis Press, 1991.

Schmemann, Alexander. *For the Life of the World: Sacraments and Orthodoxy.* Crestwood, NY: St. Vladimir's Seminary Press, 1973.

Schmemann, Alexander. *The Eucharist, Sacrament of the Kingdom.* Crestwood, NY: St. Vladimir's Seminary Press, 1988.

Schulz, Hans-Joachim. *The Byzantine Liturgy: Symbolic Structure and Faith Expression.* New York, NY: Pueblo Publishing Company, 1986.

Spidlik, Tomas. *The Spirituality of the Christian East: A Systematic Handbook.* Kalamazoo, MI: Cistercian Publications Inc., 1986.

Thunberg, Lars. *Man and the Cosmos: The Vision of St. Maximus the Confessor.* Crestwood, NY: St. Vladimir's Seminary Press, 1985.

Wybrew, Hugh. *The Orthodox Liturgy: The Development of the Eucharistic Liturgy in the Byzantine Rite.* Crestwood, NY: St. Vladimir's Seminary Press, 1990.

A priest administers Holy Communion to a young man. Orthodox mix the consecrated bread and wine in a chalice and serve Communion by means of a special spoon. Photograph courtesy St. Vladimir's Orthodox Theological Seminary.

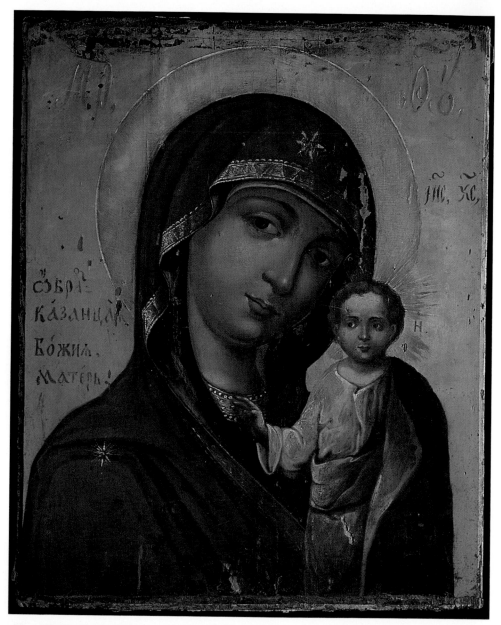

Icon: Kazan Mother of God
— Russia, mid-19th century.
Wood, oil paint, 45×57 cm.
Irkutsk Regional Museum

The Kazan Mother of God is
perhaps the most widely known
icon throughout Russia. Miracles
were first attributed to it in
1579 and it was carried by the
troops who liberated Moscow
from Poland in 1612. The style
is a typically Russian softening
of the Byzantine Hodigitria,
with the Virgin inclining her
head toward the Saviour.
(Cat. 62)

HOLY ICONS — THEOLOGY IN COLOR

Dennis G. Bell

Holy icons cannot be isolated from the rest of liturgical tradition and studied in terms of simple aesthetics. They must remain in the context of liturgy, theology, spirituality, hymnography, and architecture. All these facets of Orthodoxy augment and supplement each other. What the hymn says in words and music, the icon says in pictures.

The criteria used in evaluating liturgical art cannot be simply personal taste, pure aesthetics ("does it look nice?") or even authenticity or age, but rather how well does it convey the TRUTH? Revealed Truth, unchangeable and eternal: that in the Incarnation of Jesus Christ, the Second Person of the Holy Trinity was united to human nature, thus making salvation possible by breaking down the wall of separation between God and man, and "opened to us the doors of Paradise." As St. Athanasius put it, "God became man, so that man could become God." As a devotional object, the icon is an integral part of Orthodox Liturgy, and expresses Orthodoxy in its totality.

What exactly is an icon? "Icon" is a Greek word meaning image. This word usually invokes a negative response in light of the Second Commandment's prohibition against idolatry: "You shall not make for yourself a graven image or any likeness of anything that is in the heaven above, or that is on the earth below," and again, "All worshippers of images are put to shame, who make their boast in worthless idols." (Ps 97:7). But it was not against His peoples' making images that God directed this command, but against idolatry, to which they were prone. God did command the making of various other images, for instance, the images of Cherubim to be placed upon the Ark of the Covenant. Solomon also included images (in pure gold) of Cherubim, palm trees, open flowers, bulls, and lions in his Temple. The faithful did not confuse them with God — these images were not idols.

The reason the Old Testament prohibited images of God was that no man had ever seen God. "The Lord spoke to you out of the midst of the fire; you heard the sound of words, but saw no form; there was only a voice." (Deut 4:12). And, "No man looks on the face of God and

lives." (Ex 33:20). Moses only saw His back, while hiding under a cleft in the rock (Ex 33:21-3).

But, with the Incarnation, everything is changed. There occurred a decisive and eternal change in the relationship between God and man — between God and all material creation. The Word became flesh — God robed Himself in the garment of humanity. Jesus Christ became "the icon of the invisible God." (Col 1:15). The Old Testament prohibition against images is now revoked, as St. John of Damascus explains in his first oration:

God, Who has neither body nor form, was never represented in days of old. But now that He has come in the flesh and has lived among men, I (can) represent the appearance of God.

So we now represent the appearance of God on earth. The Apostles were privileged in that they were able to see Christ with their own eyes. We also long to hear, and to see. We still are able to hear the Lord's words from listening to Scripture, and we are still able to see His image by gazing at His icon.

A feast-day hymn clearly expresses the Church's understanding of icons:

*O Mother of God,
the Indescribable Word of the Father
took flesh through thee,
And therefore became describable;
And penetrating with His divine Beauty
the impure image of man,
He restored it to its pristine state*

*As we confess our salvation
We depict it in word and icons.*

This hymn is addressed to the Theotokos, the Mother of God, who is the icon of the Church. The confessing of the Incarnation is possible only if we also confess Mary to be the Mother of God. And to deny the icon is to deny the Incarnation; to deny the possibility of the Holy Spirit's dwelling within created matter.

The Iconographer's Task

An icon is not simply a holy picture; it does not portray a physical reality — a photographic reality — or worse, saccharin sentimentality. It rather portrays a spiritual reality — the transfigured image and likeness of the one portrayed — the deified image of the one who has returned to the original state of man's nature before the fall — before the distortion of the Image of God in which man was created. But it even goes one step further — the icon depicts humanity deified — become one with God. It reflects the two-fold dispensation of salvation: the Incarnation (the entry of the Holy Spirit into created matter) and Transfiguration (the subsequent sanctification of that matter).

Icons deliberately avoid a realistic natural look, but symbolize the transfigured, resurrected body of Christ and the saints. The glorified body, as St. Paul says, is not like the earthly body; it is a "spiritual body." (1 Cor 15:44). In this respect, the icons may appear "un-natural" (the nose is too long, the eyes too large, and so on). But if it appears un-natural to us, we are reminded that in

Icon: Calendar Icon (February) — Russia, 19th century. Wood, gesso, textile, metal leaf, tempera, 45.5×38.5 cm. Church of the Holy Ascension, Unalaska, Alaska

There are 29 days represented in four registers with a total of 65 miniature figures. Such monthly calendars are displayed as reminders of the Saints' Days. This icon received conservation treatment in 1993. (Cat. 87)

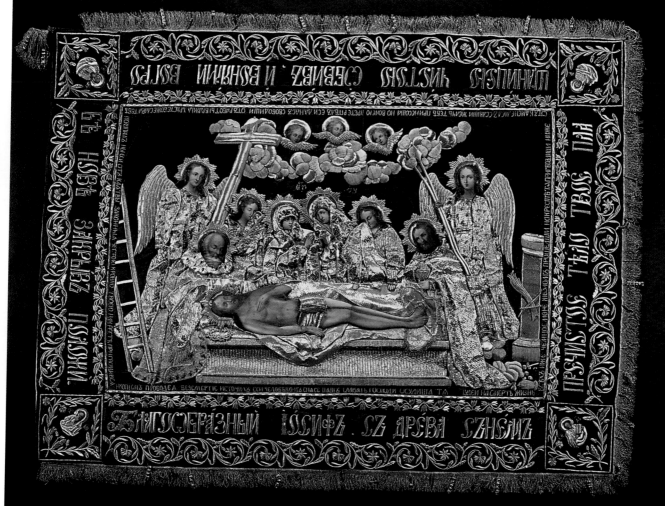

God, the order of nature is overthrown: the bush burned, but was not consumed; Israel passed through the Red Sea, but the sea remained impassable; the Virgin gave birth, but remained a virgin. These are all "types" of Biblical figures in scriptural reading, as opposed to literal or figurative interpretations.

Just as Moses' face shown brightly following his encounter with God on Mt. Sinai, and Christ radiated Divine Light on Mt. Tabor during the Transfiguration, so saints depicted on icons also radiate the uncreated light. The challenge for the artist is to illustrate this inner glow — the light source of an icon is internal, not external. The glorified body must glow through the drapery of the figure's robes. And the hand, in giving a blessing, does not cast a shadow on the area behind it, but actually enlightens this area. There are no shadows in icons.

The icon, then, is a window into Heaven, allowing us to see the deified state. What is "natural" here, may not be "natural" there. Architectural scenes indicate that an event has taken place indoors, but icons are never "shown" from inside. Therefore, architectural representations are not always accurate. Windows, doors, walls are not always in their proper places, and pillars may land on open areas, apearing to be suspended in space.

Another technique used to testify to the reversal of nature is inverse perspective. In normal perspective, the viewer's eye is drawn to a vanishing point created by a convergence of lines, which tends to give a third dimension to an otherwise two-dimensional surface. In an icon, the vanishing point is within the spectator himself, in front

Large Plashchanitsa/Shroud of Christ — Russia, late 19th century. Velvet, leather, silk, gold and silver thread, sequins, beads, cardboard, 145×205 cm. Irkutsk Regional Museum

Also called a winding sheet, the plaschanitsa is placed on the altar for veneration from Good Friday until midnight on Holy Saturday. The words "Handsome Joseph took Your Most Holy Body from the tree, he wrapped It in a clean shroud, laid You in the tomb, and enclosed it" are embroidered in Church Slavonic around the outer edge. (Cat. 42) *(Opposite)*

Icon: Mother of God of the Burning Bush — Riza made in Saratov, (Central Russia) 1875. Wood, tempera; riza: silver, 27×22 cm. Irkutsk Regional Museum

An icon with this image was first brought to Russia in the 1390s from Sinai. It is based on the passage in the Old Testament, Exodus 3:2-5 in which the Angel of the Lord appeared to Moses in a burning bush and yet the bush was not consumed. (Cat. 28)

NEEDLEWORK

In the seventeenth century, nuns at the Convent at the Cathedral of the Holy Sign *(Znamenskii Sobor)* were the first to use gold and silver thread to embroider icon cover decorations *(oklad)*. Later other embellishments became common; river pearls and Siberian semi-precious stones; amethyst, rock crystal, and tourmaline. Creating a piece of needlework is a long and arduous process. It begins with the selection of fabric which will serve as the background for the decoration. By the late eighteenth century, trade with China was providing Irkutsk, Russia with beautiful silks, brocades, and velvets. These fabrics were so exquisite that they required very little additional work. But, toward the end of the nineteenth century, the use of gold thread began to be used more extensively for embroidery. All types of gold and silver threads were combined in intricate combinations. Plain, untwisted wire was used in conjunction with twisted gold and silver thread. Embroidery was done using a variety of techniques. Sometimes thread was laid down in rows on a fabric and anchored down with very small stitches to create a pattern. Ordinary ''spun'' thread was used and combined with tiny wires which were wound into spirals and delicate metal strips. To achieve a three-dimensional effect, a rigid support, such as cardboard or birch bast, was secured to the fabric and embroidered over.

of the panel. The icon, in effect, is looking at us! Not only are icons our windows into Heaven, but also serve as Heaven's windows to earth.

An icon, then, has a sense of "other-worldliness," un-natural, not of this world. We know that in seven out of eleven post-resurrectional appearances, Christ was not immediately recognized: Mary mistook Him for the gardener; the men on the road to Emmaus didn't recognize Him until the "breaking of the bread" (which of course is interpreted in a Eucharistic sense). He appeared through closed doors, but was not a ghost. He remained flesh and blood, but "deified" flesh and blood.

There is some logic to an icon, however. The face, for instance, is proportional, based upon "moduli" measured in nose-lengths. The entire body is based on "face-lengths," each of which is equal to three "nose-lengths." An icon conforms to its prototype, and cannot reflect only the imagination of the painter. The iconographer is not an artist who is "expressing himself," but rather struggles to crucify his own ego to become completely transparent to God, through humility becoming an instrument of God's revelation.

The First Icons

There is a tradition that the first icon was made by Christ Himself. According to the *History of Evagrius,* a king from Edessa, Abgar, a leper, had heard of the healing power of Christ, and sent his ambassador Ananias to Him asking for His prayers. Because of the

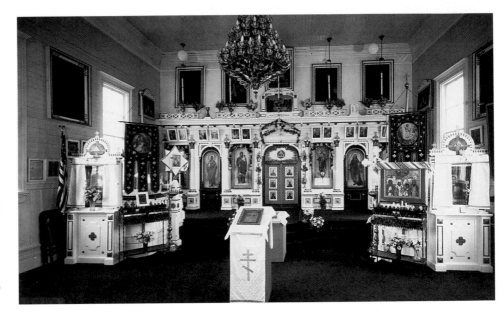

Interior of the Church of Saints Peter and Paul, St. Paul Island, Alaska. This elegant church in the middle of the Bering Sea is typical of Orthodox churches. The icon screen, or iconostas, in the background unites the congregation with the altar which is behind the screen. The Royal Doors are in the center of the screen. An icon of Christ is on the right and Mary, the Mother of God, is to the left of the Doors. Photograph courtesy Historic American Buildings Survey.

crowd, Ananias was not able to get close to the Lord, and had to content himself with sketching Him from a distance. Christ, realizing the poor man's predicament, took a linen cloth, pressed it to His Face, and gave it to Ananias, promising to send one of His disciples to Edessa after His Ascension. Disappointed, Ananias returned home and presented the linen to the king. The impression of Christ's Face was clearly visible, and the king was cured from his leprosy. This Shroud is referred to as the "Image-made-without-hands." A western version often referred to as "Veronica's Veil" and having been adopted as the Sixth Station of the Way of the Cross, records a maiden wiping the brow of Christ with a veil as He climbs towards Golgotha, and the impression of His Face remained imprinted. Historically, though, we know of no Veronica. The term comes from two words: *Vera* (true) *icona* (image). Vera icona. Veronica.

St. Luke is credited with painting the first icon of the Virgin Mary or Mother of God, as she is known to Orthodox. This achievement was accomplished while Mary was yet living, and Our Lady was said to have stated, "My grace and power are with this image," obviously enduring to serve future generations of Orthodox faithful.

The type of icon of the Mother of God painted by St. Luke is referred to as "Hodighitria," which means "She Who Points the Way." Both the Virgin and Child are turned full-face toward the spectator, and her hand, pointing to the Christ Child, emphasizes His divinity.

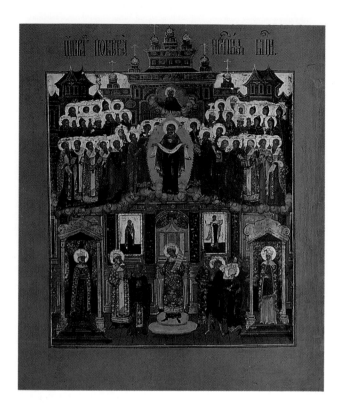

Icon: Protection of the Most Holy Mother of God — Russia, n.d. Wood, paint, gold leaf, 31.2×26.8 cm. St. Michael Cathedral, Sitka, Alaska

An icon of remarkable complexity; each face is carefully detailed. The feast of the Protection or "Intercession" of the Mother of God was introduced in Russia in the 13th century, and depicts the Virgin holding her veil over the worshipers in the church. (Cat. 74)

Another image is the type "Umilenie," or "Our Lady of Tenderness," which represents the mutual caress of Mother and Child, and is the image of a mother who suffers deeply for the inevitable suffering which awaits her Child. The Vladimir Mother of God is perhaps the most famous of this type.

Tradition early established important characteristics of saints depicted on icons. We can trace portrayals of St. Peter, for instance, back to a fourth century glass from the catacombs, and even earlier to a Roman medallion of the second century. In each case, his distinguishing features remain virtually unchanged: curly hair, a forelock, and a rounded white beard. Paul and Andrew have similar early prototypes.

The Church as Icon

If Mary is the icon, or image, of the Church, the church herself is the icon of the Kingdom of God. The church, as the Ark of Salvation, is built according to the plans of the Tabernacle of Moses, and the Temple of Solomon. It faces east, towards paradise, awaiting Christ, the Sun of Righteousness, the Orient from on High, and awaiting the dawn of the day without end.

The sanctuary represents Heaven, the "Holy of Holies" reserved for the High Priest (the clergy); the nave, deified earth, represents the "Holy" of the Tabernacle, for the royal priesthood (the laity); and the narthex, or vestibule, represents unredeemed creation, the world.

Between the altar and the nave, between Heaven and earth, is an icon screen called the iconostas, through which the clergy (representing Christ) pass, uniting Heaven and earth. Contrary to popular belief, the icon screen is not meant to separate the altar from the nave, but serves as the horizon point which connects Heaven and earth. During the Liturgy, the faithful may contemplate these windows into Heaven. The arrangement of icons on the iconostas is rather standard. A pair of doors through which the priest brings the Holy Eucharist are in the center; they are called the Royal Doors and on them are displayed icons of the four Evangelists — Matthew, Mark, Luke, and John — and of the Annunciation. On either side of the Royal Doors are icons of Christ and the Mother of God. On two doors near either end of the iconostas, the Deacons' Doors, are sainted deacons or archangels. On the far side of these doors are icons of St. John the Baptist (the Forerunner) and the patron saint of the Church. Above the Royal Doors is an icon of the Mystical (Last) Supper. The row of icons above that is called the Deesis (Christ surrounded by saints). If there are additional rows, they may contain festal icons (feast days of the Church, including the Annunciation, Nativity, Transfiguration, and Ascension). Above that, Old Testament prophets, and finally a top row may contain Old Testament patriarchs.

The icons around the Royal Doors are images occupying space, but represent the movement of the present through time: the icon of the Mother of God represents Christ's

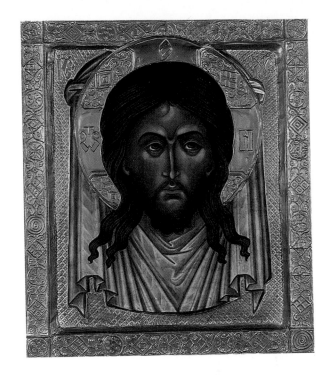

Icon: Savior Not Created by Human Hands — By the hand of Tamara Elchaninov, 1950s, Paris, France. Wood, gesso, tempera; riza: silver, 71×51 cm. St. Vladimir's Orthodox Theological Seminary, New York

The image of the head of Christ as an icon derives from the legend of the miraculous transfer of Christ's face to a cloth which he used to wipe his face. Icons of this image date from the 12th century. (Cat. 149)

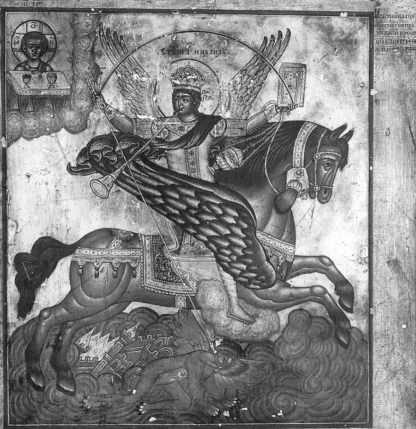

Icon: Old Testament Trinity
— Russia, n.d. Brass castwork, enamel, 20×16.5 cm. The James Family
(Cat. 118)

Icon: Archangel Michael, Commander of the Mighty Forces — Russia, 18th century. Wood, tempera, gold leaf, 35×29 cm. Irkutsk Regional Museum

Princes going into battle would appeal to St. Michael for intercession in their campaigns. Here, Archangel Michael announces the triumph of Good over Evil through the instrument of Christ. He has loosed a spear which has struck the devil. (Cat. 64) *(Opposite)*

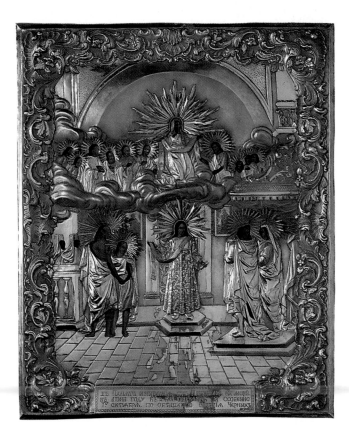

Icon: Protection of the Most Holy Mother of God — Russia, 1843. Wood, paint; oklad: gilded silver, 44.5×35.5 cm. St. Michael Cathedral, Sitka, Alaska

The icon bears the inscription, "In memory of deliverance from destruction on the sea in the year 1842 . . . as promised by George Tchernyk." This refers to a shipwreck that occurred a few hundred miles southwest of Sitka. It was commissioned by a survivor of the storm and was made especially for the Cathedral in Sitka. (Cat. 76)

first coming as Immanu-El, Son of the Virgin (past event in history); the icon of Christ on the right represents His coming in Glory (in the future); while on the altar table in the middle, between the past and the future, Christ is with us presently, now, in the Eucharist.

The icon, like the Eucharist, is a continuous re-occurrence of the Incarnation — the descent of the Holy Spirit into created matter. So the Theotokos occupies the space immediately above the altar, receiving the Holy Spirit from above, uniting it to human nature from below. Also pictured in the sanctuary are the Church Fathers, authors of the liturgies, hierarchs, deacons, concelebrants, and the Communion of the Apostles.

Inside the dome, which represents the vault of Heaven, is Christ the Pantocrator (Ruler of the Universe) — the Head of the Church, announced by the prophets, established by the Apostles (below the dome) and supported by the four Evangelists, who spread the Good News to the four corners of the earth. The pillars of the church are the martyrs, hierarchs, and ascetics. The walls depict important events in the New Testament (the Sermon on the Mount, Entry into Jerusalem, parables, and miracles). At the back of the church is depicted the Last Judgment — the beginning of the age to come. The church is an icon of the Body of Christ. It is the Kingdom of Heaven as it already exists on earth, and anticipates its coming in Glory.

Veneration of Icons

Those outside the Church who observe Orthodox faithful venerating icons wonder if this borders on idolatry.

We must clarify a few terms. The Greek fathers understood the distinction between *proskynesis* (veneration, bowing down) and *latreia* (absolute worship, adoration). Veneration is due to kings, ancestors, elders, and fellow humans. There are many scriptural examples of veneration (Abraham to the sons of Hamor, Jacob to his brothers Esau and Joseph, Joshua and Daniel venerated the Angel of God). Worship (adoration) is due to God alone. We worship God; we venerate icons.

The Church does not "use" icons; they are central to its life, a part of its faith. The icon serves as an intermediary: we venerate an icon, and our prayers rise to the prototype depicted; the icon participates in the holiness of its prototype, and through the icon, we do also, through our prayers.

In Orthodox tradition, every family has a prayer corner, no matter how humble or sublime the residence, where the family gathers for prayer. The family becomes a "miniature church," as St. Paul says, with the father as head, as Christ is of the Church, but willing to sacrifice Himself for her. (Eph 5:23)

The icon also has a teaching role: it shows theology in color. St. Basil the Great says that icons are the books of the illiterate. "We comprehend through our physical ears, spiritual words. Contemplation with our physical eyes likewise leads to spiritual contemplation." What does an icon tell us? We know that it reveals Divine Truth. We can examine other teaching aspects of the icon. An icon of a saint, for example, will often have scenes from his life depicted around the border. At no

Icon: St. Herman of Alaska
— By the hand of Eleanor
Naumoff, Old Harbor, Alaska,
1992. Glass beads, 36×29 cm.
Church of the Three Saints,
Old Harbor, Alaska

Beading is an ancient Koniag
tradition, most often used for
decoration. The use of beads to
create an icon is unique to this
talented Koniag iconographer
from a village on Kodiak
Island. (Cat. 100)

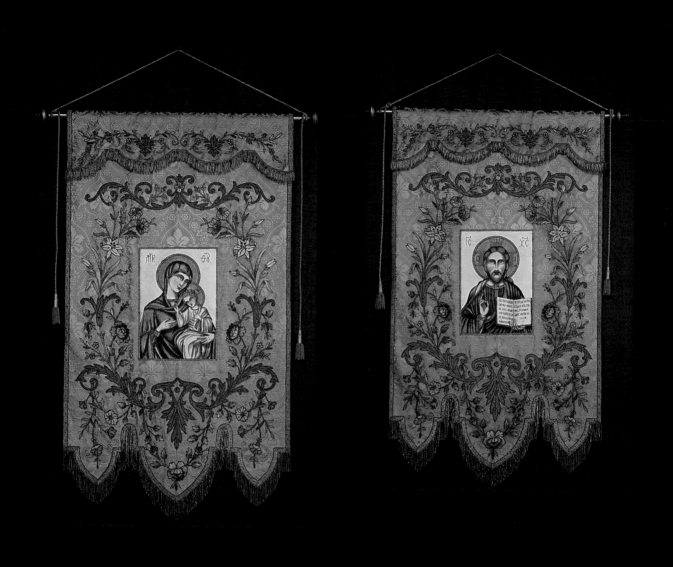

Icon: St. John the Evangelist
— Early 19th century. Canvas, oil, wood, 30×26 cm. Church of the Holy Ascension, Unalaska

This icon from a set of Royal Doors in the village of Kashega on Unalaska Island may have been written by the Aleut artist Vasily Kruikov, who was trained by Father John Veniaminov (St. Innocent). (Cat. 93)

time, however, is a saint depicted in profile. Profile is the beginning of absence.

Festal icons convey the same theological and dogmatic truths as the liturgical hymns for the feast. Compare an icon of the Nativity with the feast day Kontakion:

> *Today the Virgin gives birth to the Transcendent One and the earth offers a cave to the Unapproachable One! Angels, with shepherds, glorify Him! The wise men journey with a star! Since for our sake the Eternal God was born as a little child!*

Further examination and comparison of festal icons with their liturgical hymns would reinforce and demonstrate the consistency and inseparable relationship between iconography, hymnography, and liturgy.

Banners — France, 1960. Silk, embroidery, 132×75 cm. each, St. Mary's Romanian Orthodox Church, Cleveland, Ohio

The icons on each of these banners of Christ and the Mother of God are done in such fine hand embroidery that they appear as if painted. The decorative scrollwork on the surround is also hand-embroidered. Such banners are displayed in the nave of the church in front of the iconostas. (Cat. 192, 193) *(Opposite)*

Icon: Archangel Gabriel —
Russia, mid-18th century.
Wood, tempera, gold leaf,
53×42 cm. Irkutsk Regional
Museum

Archangel Gabriel is venerated
as the bearer of joyful news who
foretold both the birth of John
the Baptist and Christ himself.
This icon is Baroque in style
and is probably from a left
Royal Door. It stands before
the altar and is usually paired
with the Mother of God of the
Annunciation on the right door.
The Baroque style flourished in
Siberia, not only in icon paint-
ing but also in architecture and
crafts. (Cat. 63)

The "Writing" of an Icon

The Church stipulates that icons be painted "as they were painted by the ancient and holy iconographers." Imitation is not a bad thing, but is to be desired: "Be imitators of me, as I am of Christ," wrote St. Paul. To be an image (icon), it must be an image of something, necessarily a copy. The iconographer is literally an "icon-writer," and should make the same effort at accuracy as a monk copying the text of the Gospel. There is a close relationship between calligraphy and icon-writing.

Colors, poses, and inscriptions are usually dictated by tradition to conform to the original, although it is still possible to detect eras, periods, places, styles, and even individual hands (although iconographers never sign their work). Bishops are shown in vestments of their office. Martyrs are often shown in red robes, and may carry a cross. (The means of their martyrdom are not depicted — their particular means of suffering is not important, but only their victorious deification.) A white veil denotes chastity. Prophets will usually carry a scroll. Warrior saints will often be shown in armor. (As an aside — St. George rides a white horse, St. Demetrius rides a black one, although often other "un-natural" colors will be used.) Kings, queens, and princes are shown wearing crowns.

Iconography is one of the traditions of the Church, as are three immersions in Baptism, praying facing the East (awaiting the dawn of the eighth day, the day of re-creation), the manner of receiving the Holy Eucharist, etc. St. Paul tells us: "So then, brethren, stand firm and hold to the traditions which you were taught by us, either by word of mouth or by letter." (2 Thess 2:15). And again, in 1 Cor 11:2, "I commend you because you remember me in everything, and maintain the traditions even as I have delivered them to you."

Once a painter leaves the tradition, and goes off on his own, all kinds of problems arise. If it is possible to distort Truth in words, how much easier is it to distort Truth through images! One temptation Eastern Christians face is the influence of the West, particularly the Italian Renaissance. The danger of accepting western art into the Orthodox Church is that it does not represent deification. The West understands sanctified man as a vessel which contains created grace, much like a glass which contains water. The Orthodox icon presents sanctified man entirely transfigured from within, deified by the grace of God, much like an iron horseshoe which radiates heat and light after being taken from the blacksmith's furnace. Western religious art emphasizes the humanity of Christ, particularly His human suffering, and invokes the emotions and senses of our human nature. The Italian "holy picture" shows God in the image of man!

During the 1700s, Peter the Great, and his imperial successors, attempted to bring Russian social, military, and artistic standards up to par with their western counterparts. They sent their most promising artists and musicians abroad to study in Italy and France. Some of this art began to infiltrate the church as painters lost sight of the theological significance of the holy icons. Much of the sacred art brought to America

during the nineteenth and early twentieth centuries reflected this period of "western captivity," and it has only been since the middle of this century that the Orthodox Church has been seeking to return to its traditional form of iconography.

How then, is an icon made? First of all, the painter himself undergoes extensive preparation. There is a spiritual discipline to which the iconographer must submit, once he has received the blessing from the bishop to undertake the ministry (usually only after years of technical and spiritual training). Icon painting cannot simply be a secular "hobby" with a religious theme. It is a serious calling and vocation within the Church, as is ordination to the priesthood. The iconographer then receives the sacraments of confession and communion, and enters into a period of prayer and fasting, asking prayers of intercession from the saints he is about to portray. Even the paints and brushes are customarily blessed before work begins, as are the materials used in the icon.

The painter will begin with a non-resinous wood (birch and linden are favorites), and traditionally a groove is cut across the back of the panel, and a strut inserted to prevent warping. The panel is sanded, and perhaps a recessed area is routed out of the middle, leaving a natural "frame." Loose linen is then glued to the front of the board, and a substance called gesso is applied. Gesso is a mixture of alabaster or chalk and rabbit-skin glue.

Several thin layers are necessary to cover the grain in the wood. The board is then wet-sanded to achieve a perfectly smooth glassy surface to serve as a ground to hold the paint.

A drawing may be done on a separate sheet of paper, and later transferred to the prepared panel. With a sharp etching tool or scriber, the sketch is inscribed into the gesso, so that the lines will still be visible after the base colors are applied. A skilled iconographer may "write" the outline directly on the panel, or may lay out the figure in ochre with a wider brush, then refine the drawing with finer sienna lines. The first colors to go on are all dark base colors. An iconographer begins with dark background colors, and works his way to the lighter ones, much like a spiritual pilgrim who begins his journey in the darkness, and comes to the light. Flesh tones begin as a dark olive color; even white begins as a shade of tan.

The pigments used in iconography originally were colored pigment powders mixed with egg yolk (egg tempera), which allows for layering of successive translucent coats of brighter colors, one on top of the other, forming a barely perceptible relief or sculpture, wherein the highlighted areas (i.e. the tip of the nose) would actually be higher than the rest of the area around it. It is interesting to note that even when oil painting was introduced in Western Europe, the Orthodox rejected its use as not being compatible with the aims of iconography — oil paint produced a "sensuous" characteristic, and did not lend itself to the layering method.

After the iconographer colors in all open areas, he then recreates the lines that were etched in by the scriber,

Icon: St. John the Forerunner — By the hand of Yuri Sidorenko, Eagle River, Alaska, 1990. Wood, acrylic, St. John's Orthodox Cathedral (Antiochian), Eagle River, Alaska

St. John the Baptist is known to the Orthodox most commonly as The Forerunner of Christ, or God's messenger prophesied in the Book of Isaiah. He is shown in clothing made of camel's hair described in the Gospel of Mark 1:6. (Cat. 95)

using black, brown, or a dark shade of the base color. Then the painter develops each color by overpainting increasingly lighter values of each hue, concentrating the light to restricted areas in order to achieve the "glow" that indicates theosis, or sanctity. After the flesh tones and clothing have been modeled and highlighted, the background and halo are primed for gilding. Gilding is accomplished by applying an adhesive called sizing (gold size) to the area to be gilded. This is then covered with thin sheets of 23 karat gold leaf. The excess gold is then removed, and the surface burnished (often by rubbing it with a hound's tooth). After lettering and labeling, the icon is varnished and allowed to dry. Originally, olipha (boiled linseed oil) was used to protect the icon and enrich the colors, but its tacky surface would collect dust and carbon from the burnt oil in the vigil lamps, and the surface would become darkened. Today, it is desirable to use a polyurethane varnish, which also prevents the colors from fading.

And finally the icon is finished, ready to be blessed on the altar, and to assume its role as a channel of divine grace between Heaven and earth.

Author

Dennis Bell, music teacher and choir director at St. Nicholas Orthodox Church in Mentor, Ohio, was a student of master iconographer Theodore Jurewicz and has been writing icons since 1978. His icons are found in churches and homes in America, Europe, and the Middle East. He is president of the St. John of Damascus Iconographic Society.

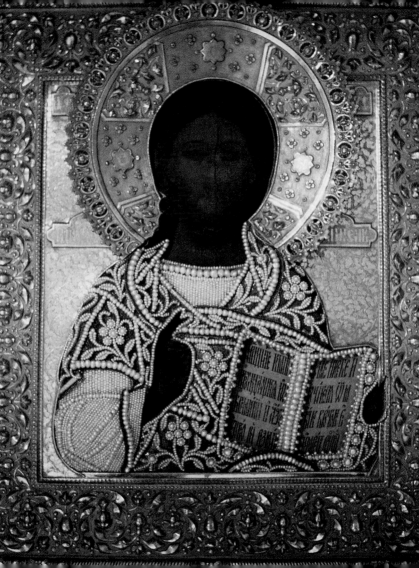

Suggested Readings

An Iconpainter's Patternbook: The Sroganov Tradition. Translated by Fr. Christopher Kelly. Torrance, CA: Oakwood Publications, 1992.

"Painter's Manual" of Dionysius of Fourna. Translated by Paul Hetherington. Torrance, CA: Oakwood Publications, 1991.

Ouspensky, Leonid. *Theology of the Icon.* Crestwood, NY: St. Vladimir's Seminary Press, 1987.

Ouspensky, Leonid and Vladimir Lossky. *The Meaning of Icons.* Translated by Palmer and Kadloubovsky. Crestwood, NY: St. Vladimir's Seminary Press, 1982.

Rice, David and Tamara Talbot. *Icons and Their History.* Woodstock, NY: Overlook Press, 1974.

Sendler, Egon. *The Icon: Image of the Invisible.* Translated by Fr. Steven Bigham. Torrance, CA: Oakwood Publications, 1988.

Weitzmann, Kurt et. al. *The Icon.* New York, NY: Dorset Press, 1987.

Icon: Christ — Russia, 1870. Wood, paint, gold leaf; riza: Russian white gold, cultured pearls, 30.5×26.7 cm. Holy Trinity Orthodox Cathedral, Chicago, Illinois

This icon of Christ was a gift to the Orthodox Cathedral in Chicago by Princess Alexandra of Russia, daughter of Prince Paul Golitzin, head of the Security Services for Tsar Nicholas II. Princess Alexandra now lives in Chicago. She acquired the icon 1978–1980. (Cat. 181) *(Opposite)*

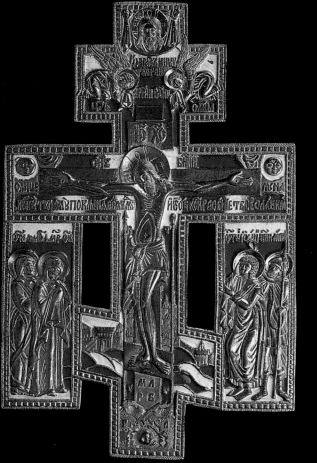

Icon: Crucifixion — Russia, late 18th, early 19th century. Brass castwork, white and blue enamel, 22.5×14.5 cm. Irkutsk Regional Museum

This icon of the Crucifixion features saints along the sides, the image of "Christ Made Without Hands," and the sun and the moon above. (Cat. 51)

". . . and you in turn shall summon nations you do not know,
and nations that do not know you shall come running to you. . ."
Isaiah 55:4-5

CHRONOLOGY

1727 — January 15, Bishop Innocent (Kul'chitsky) establishes the Diocese of Irkutsk as an independent see; it is founded on the principle of missionary work.

1741 — July, Captains Vitus Bering and Aleksei J. Chirikov sight Alaska from their Russian ships.

1759-1761 — Stepan Glotov sails the small ship "Julian" to Umnak Island in the Aleutians. During his two-year stay, he baptizes an Aleut boy, naming him Ivan. This is the first Orthodox Christian baptism in America.

1788 — Gregory Shelikov, a merchant active in Alaska, visits the Russian Monastery of Valaamo on Lake Ladoga and recognizes the value of sending missionaries to Russian America from this region. He makes a formal request to Empress Catherine II for a religious mission to Kodiak.

1793 — Empress Catherine directs the Most Reverend Gabriel, Metropolitan of St. Petersburg to recruit missionaries from Valaamo Monastery.

On December 25, eight monks leave St. Petersburg for America: Archimandrite Ioasaph (Archimandrite of Valaamo Monastery and head of the mission), Monk

Herman, Monk Ioasaph, Priest-monk Makary, Priest-monk Juvenaly, Priest-monk Afanasy, Deacon-monk Nectary, and Deacon-monk Stepan. (Herman, who was canonized in 1970, became the first American saint of the Orthodox Church.)

1794 — September 24, the first Orthodox missionaries arrive at Kodiak Island. The journey of 293 days and 7,327 miles was the longest missionary journey in the history of the Orthodox Church.

November 21, The Church of the Holy Resurrection is founded on Kodiak Island.

1796 — September 29, Hieromonk Juvenaly is martyred by Alaska Natives.

1798 — April 10, Ioasaph (Bolotov), Archimandrite and head of the mission, is consecrated in Irkutsk as the first Orthodox bishop for America.

1799 — The Russian-American Company is formed.

Bishop Ioasaph (Bolotov) dies at sea returning to Alaska from Irkutsk.

1802-1806 — St. Petersburg Holy Synod sends Hieromonk Gideon to Alaska to inspect the mission

and to teach. A school is founded at Kodiak. Gideon begins work on an Aleut dictionary.

1804 — Bishop Innocent of Irkutsk is canonized a saint by the Orthodox Church of Russia.

1808 — The capital of Russian America is moved from Kodiak to Sitka (New Archangel). The first church is built in Sitka dedicated to the Archangel Michael.

1812 — The Chapel of St. Helen is established at Fort Ross, California.

1816 — Peter the Aleut is martyred in California.

1820 — Siberia is divided into western and eastern parts. The Irkutsk Diocese in the east includes: the Baikal area, Yakutsk, the Daur, Okhotsk, Kamchatka and Russian America.

1824 — John (Ioann) Veniaminov, 27-year-old priest from Irkutsk, arrives at Unalaska. He establishes a church dedicated to the Ascension of Our Lord, a school, and Alaska's first meteorological station. The church is consecrated on July 29, **1826**. Father John serves at Unalaska until **1834**.

1824-1834 — Priest John Veniaminov translates the Gospel of St. Matthew, parts of the Divine Liturgy and the catechism into Aleut, for which he creates an alphabet from the Cyrillic, a dictionary, a grammar and a primer. He also compiles a three-volume ethnographic work: *Notes on the Islands of the Unalashka District.*

1828 — Jacob Netsvetov, the first Creole (Aleut-Russian) priest, trained at Irkutsk Seminary, arrives to serve his home community on Atka Island.

1834 — Priest John Veniaminov moves to Sitka. He visits Fort Ross in **1836.**

1837 — December 13, Father Herman, the last survivor of the original party of missionaries to Alaska, dies on Spruce Island, near Kodiak.

1839 — Priest John Veniaminov's *Notes on the Islands of the Unalashka District* is published in St. Petersburg and his proposal to the Russian Holy Synod for restructuring the Alaskan mission is presented and accepted in St. Petersburg, Russia. The same year his wife dies.

1840 — The American Mission is removed from the jurisdiction of the Diocese of Irkutsk and given elevated status under its own bishop. Priest John Veniaminov takes the monastic name of Innocent and is consecrated, on December 15, as Bishop of Kamchatka, the Kurile and the Aleutian Islands, with the diocesan see at Sitka.

1841 — Russian holdings at Fort Ross are sold to American citizen John Sutter.

1842 — Priest Jacob Netsvetov is awarded the Pectoral Cross by the Russian Holy Synod for his translation of the Gospels into the Atkan dialect.

1843 — In Sitka, the Mission House, including the Bishop's residence and the Annunciation Chapel, is dedicated.

1844-1848 — St. Michael Cathedral is constructed in Sitka, the first Orthodox Cathedral in North America.

1845 — Kivkhpak Mission is founded at Ikogmiut on the Kivkhpak (Yukon) River and has jurisdiction for

THE AWESOME JUDGMENT

Icon: Last Judgment — By the hand of Bishop Job (Osacky), early 1970s, United States. Particle board, acrylic, gold leaf, 79×60 cm. St. Sergius Chapel, Chancery, Orthodox Church in America

This icon is inspired by an iconic print which is found in Alaskan Orthodox churches at the church exit. It was commissioned by Metropolitan Theodosius, following his years as Bishop of Alaska. (Cat. 135)

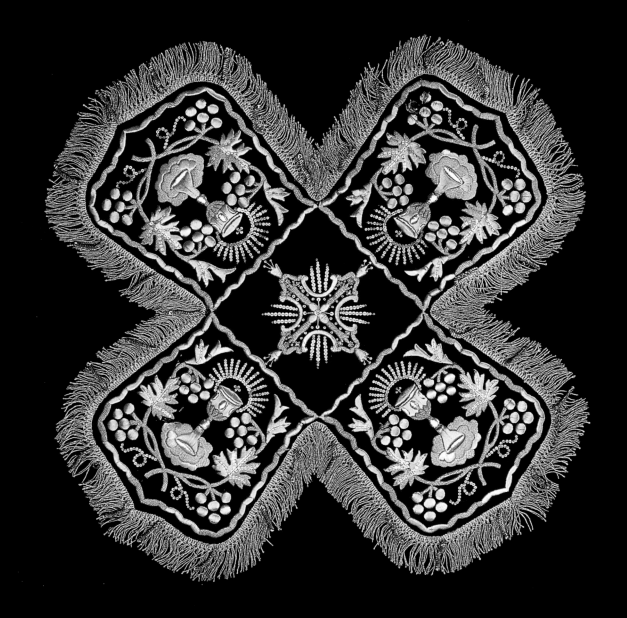

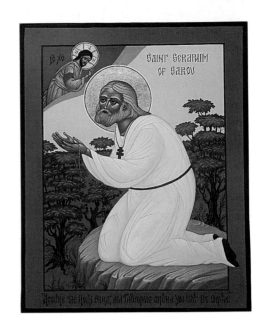

Chalice Cover — Russia, late 19th century. Velvet, gold thread, pearls, sequins. 47×47 cm. Irkutsk Regional Museum (Cat. 37) *(Opposite)*

the Yukon and Kuskokwim regions. Priest Jacob Netsvetov is appointed to head the new mission.

The Missionary School at Sitka opens and offers Native language study (Aleut, Eskimo and Tlingit), medicine and Latin. Twenty-three students, all Native or Creole, enroll.

1848 — Jacob Netsvetov is raised to the rank of archpriest.

1852 — Bishop Innocent is given charge of the Yakutsk Diocese in Siberia and is elevated to archbishop. He moves his residence permanently to Yakutsk.

1858 — Seminary at Sitka is transferred to Yakutsk in Siberia.

Icon: St. Seraphim of Sarov — By the hand of Robin Armstrong, Eagle River, Alaska, 1994. Wood, acrylic, 28×23 cm. St. John's Orthodox Cathedral (Antiochian), Eagle River, Alaska

This is a contemporary icon of St. Seraphim of Sarov, an 18th century hermit who was canonized in 1905 in Russia. He was a humble monk, much revered for his wisdom; his counsel was sought by princes as well as peasants. (Cat. 94)

Epitrakhil — St. Petersburg, 1750. Gold and silver thread, silk thread, silk, 141×27 cm. Irkutsk Regional Museum

St. John Chrysostom (347–407) is featured in this detail from an epitrakhil belonging to St. Sofroni, Bishop of Irkutsk from 1753–1771. The whole vestment features eight saints delicately embroidered using a technique known as "face" embroidery. (Cat. 8)

1859 — January 6, the Alaskan Diocese is reduced to the status of an auxiliary see to the Kamchatka Diocese and Peter (Lysakov), Archimandrite and former Rector of the Seminary at Sitka, is consecrated in Irkutsk as Vicar Bishop of Alaska.

July 19, celebration in Yakutsk, for the first time, of the Liturgy entirely in the Yakut language, based on translations by Archbishop Innocent (Veniaminov).

1860 — Government report estimates the number of Native Alaskan Christians at 12,000, in 43 communities, with 35 chapels, 9 churches (2 in Sitka), 17 schools and three or four orphanages.

1862-1864 — First Orthodox parishes in Galveston and New Orleans are founded as mixed ethnic parishes.

1862 — December, Archpriest Jacob Netsvetov turns over his duties at Kvikhpak (Yukon) Mission to Hieromonk Illarion.

1864 — July, Archpriest Jacob Netsvetov dies in Sitka, where he is buried.

1867 — Russia sells Alaska to the United States for $7,200,000.

The Bishop of Alaska initiates the first formal inquiry into the life of the monk, Father Herman.

Bishop Paul (Popov) replaces Bishop Peter; he serves until 1870.

1868 — Archbishop Innocent of Yakutsk is selected by the Holy Synod of Russia as Metropolitan of Moscow, the highest rank in the Russian Church at that time.

Metropolitan Innocent issues his "Instructions to Missionaries in Alaska," concerning attitudes toward Native peoples, a pioneer work in cultural tolerance.

The First Orthodox parish is founded in San Francisco, California, composed of Greeks, Russians and Serbians, with services in several languages (including English) and meetings in English.

1870 — In view of U.S. sovereignty in Alaska, the Holy Synod creates the Diocese of Alaska and the Aleutian Islands on June 10. Bishop Paul is transferred to Russia and Bishop John (Mitropolsky) is appointed bishop of the new diocese.

Metropolitan Innocent founds the Russian Imperial Missionary Society to raise funds for the American Church.

Aleut Gospel — St. Petersburg, Russia, 1840. Paper, embossed nickel/silver. 28×18×4.2 cm. Church of the Holy Ascension, Unalaska, Alaska

St. Innocent, when he served as missionary priest at Unalaska, developed the Aleut orthography and translated the Gospels into Aleut. This volume contains parallel texts in Church Slavonic and Aleut, and is a first edition. The Gospel is inscribed and annotated in the hand of St. Innocent. (Cat. 97)

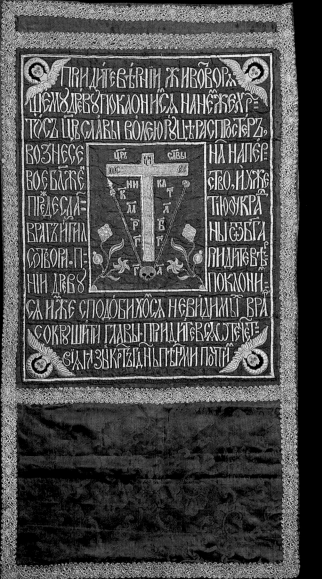

ПРИДИТЕ ВѢРНІИ ЖИВОВОРА
ЩЕМУ ДРЕВУ ПОКЛОНИСА НАНЕМЖЕ ХР҃
ТОСЪ ЦР҃Ь СЛАВЫ ВОЛЕЮ РУЦѢ РАСПРОСТЕРЪ,
ВОЗНЕСЕ ЦР҃Ь СЛАВЫ НА НАПЕР
ВОЕ БЛ҃ЖЕ СТВО, И ѦЖЕ
ПРЕДЕСЛА ТІЮ ОУКРА
ВРАГИ НГИЛ НЫ СУБОГА
СОТВОРИ. П- РИДИТЕ ВѢ
НІИ ДРЕВУ ПОКЛОНИ-
СА ИЖЕ СПОДОБИХОСА НЕВИДИМІ ВРА
СОКРУШИТИ ГЛАВЫ ПРИДИТЕ ВѢ ЯСТЕТЕ-
СѦ ИЗУКРТ҃ГАН Ы ПѢНИИ ПОТИ

Tropar — Irkutsk, late 19th century. Silk, lace, silk thread, sequins, gold and silver thread 113×59 cm. Irkutsk Regional Museum

This banner was made in Irkutsk. The lettering is a prayer proclaiming the power of the Church. (Cat. 38)

Holy Trinity Greco-Russian parish is organized in New York City by Father Nicholas Bjerring.

1872 — Bishop John unofficially moves the bishop's see from Sitka to San Francisco. This move is officially sanctioned under Bishop Nestor (1879-1882).

1877 — Bishop John returns to Russia and the see is vacant for two years.

1879 — Bishop Nestor (Zakkis) is appointed Bishop of Alaska and the Aleutian Islands.

Metropolitan Innocent dies in Moscow on March 31 at the age of 82.

1882 — Bishop Nestor perishes at sea in Alaskan waters. His body is recovered and buried at Unalaska beside the Church of the Holy Ascension. The see remains vacant until 1888.

1885 — Greco-Slavonic Brotherhood is formed by Greek and Slavic immigrants in Chicago to provide religious services for the Orthodox community.

1888 — Vladimir (Basil Sokolovsky) is consecrated Bishop of Alaska and the Aleutian Islands; he serves until 1891.

Pastoral school for readers and choir directors is created by Bishop Vladimir in San Francisco with 24 students.

Father Sebastian Dabovitch is ordained; he is the first American-born to be ordained an Orthodox priest in America.

Tserkovnyia vedomosti (Church News) begins publication in St. Petersburg as the official journal of the Holy Synod.

1891 — Holy Virgin Protection Parish, Minneapolis, Minnesota, organized in 1887 and led by Father Alexis Toth, is the first Uniate parish in America to return to Orthodoxy.

Bishop Nicholas (Michael Z. Ziorov) is consecrated Bishop of Alaska and the Aleutian Islands; he serves until 1898.

1892 — The first Serbian parish in America is founded in Jackson, California, by Archimandrite Sebastian Dabovich.

St. Vladimir's Russian and Annunciation Greek Orthodox parishes are founded in Chicago.

1895 — First church for Arabic-speaking Orthodox is founded in Brooklyn, New York.

The Orthodox Mutual Aid Society (ROCMAS) is established, April 1, 1895.

1896 — Father Alexander Hotovitzky begins editing, in New York, the *Russian Orthodox American Messenger*, a bilingual publication in Russian and English, for the diocese.

1897 — The Minneapolis Missionary School opens October 1.

Nicholas B. Orlov is commissioned to translate the Horologian and the General Menaion into English for use in the diocese.

The first Russian Orthodox missionary priests travel to Canada.

1898 — Bishop Nicholas is called back to Russia; Bishop Tikhon (Belavin), Vicar Bishop of the Diocese of Lublin, is appointed Bishop of Alaska and the Aleutian Islands.

1900 — Holy Synod in Russia changes the name of the Diocese of Alaska and the Aleutian Islands to "Aleutian Islands and North America."

Construction begins on Holy Trinity Cathedral in Chicago, designed by Louis Sullivan, and under the supervision of the priest John Kochurov.

1901 — The first Orthodox Church in Canada is constructed at Vostok, Alberta.

1902 — November, construction begins in New York City on a permanent Orthodox Church, St. Nicholas Cathedral, to replace the home chapel in use. Father Alexander Hotovitizky serves as dean until 1914.

1903 — Alaska becomes a vicariate within the Diocese of the Aleutian Islands and North America and Bishop Innocent (Pustynsky) is named vicar bishop.

1904 — Brooklyn becomes a vicariate within the Diocese for the Syro-Arabic Mission. Archimandrite Raphael (Hawaweeny) is consecrated Bishop of Brooklyn. He is the first Orthodox bishop to be consecrated in the United States.

The first Romanian Orthodox parish is organized in Cleveland, Ohio.

1905 — Bishop Tikhon transfers the episcopal see from San Francisco to New York City. Bishop Tikhon is elevated to archbishop.

The missionary school in Minneapolis is reorganized by Archbishop Tikhon into the Orthodox Theological Seminary of North America, June 1, 1905. The missionary school is moved to Cleveland, May 6.

The Hellenic Eastern Christian Orthodox Church is incorporated in the state of New York.

The Russian Monastery of St. Tikhon of Zadonsk opens in South Canaan, Pennsylvania. An orphanage is attached to the monastery.

1906 — The Chukchi Peninsula in Siberia is transferred by the Holy Synod in Russia to the jurisdiction of the Alaska vicariate.

The Service Book of the Holy Orthodox Catholic Church, commissioned by Archbishop Tikhon, is published in English.

1907 — The First All-American Church Sobor (Council) meets in Mayfield, Pennsylvania, convened by Archbishop Tikhon.

Archbishop Tikhon leaves for Russia in March.

Archbishop Platon (Rozhdestvensky) succeeds Archbishop Tikhon as head of the Diocese of the Aleutian Islands and North America, serving to 1914.

The first Bulgarian Orthodox parish is established in Madison, Illinois.

Russian Immigrants' Brotherhood and Home is opened in New York.

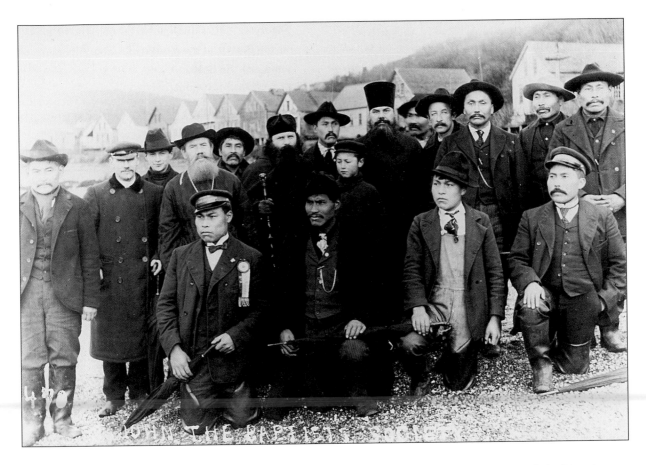

Bishop Nicholas (Ziorov) — with the staff — is shown surrounded by members of the Tlingit Indian John the Baptist Brotherhood at Kilisnoo, Alaska, ca 1896. The local priest Rev. John Soboleff, is the man with the grey beard. Photograph courtesy Alaska State Library.

The Russian Immigrant Home in New York City was a haven for the flood of newcomers who reached America in the early 1900s. The impact of this Slavic immigration on Orthodoxy in America was profound shifting its focus from Alaska and California to New York, Pennsylvania, New England, and the Midwest. Photograph courtesy Archives, Orthodox Church in America.

Theophan Noli is ordained to the priesthood by Archbishop Platon, at the request of a large Albanian community in Boston.

1912 — Archbishop Platon transfers the Theological Seminary from Minneapolis to Tenafly, New Jersey.

In Southbridge, Massachusetts services are held for the first time in the Albanian language at the new Orthodox Church of St. Nicholas.

1913 — Serbian clergy meet in Chicago to secede from the diocese and join the jurisdiction of the Serbian Metropolitan of Belgrade.

1914 — Archbishop Evdokim succeeds Archbishop Platon as head of the Diocese of the Aleutian Islands and North America. Archbishop Platon returns to Russia.

1915 — The Orthodox Women's College is organized in Brooklyn; it exists for one year on a high school-junior college level with 12 students.

The first women's monastery (convent) and orphanage is organized in Springfield, Vermont. It is dedicated to the memory of Father Alexis Toth.

1916 — A vicariate for Canada is created and Alexander (Nemolovsky) is consecrated bishop.

A vicariate of Pittsburgh is created and Archimandrite Stephen (Dzubay) is consecrated bishop for the largely Ugro-Russian community.

1917 — Russian Revolution ends Russian support for Orthodox Church in North America.

All-Russian Sobor (Council) makes wide-ranging reforms in the administration of the Russian Orthodox Church, an event unrelated to the Bolshevik Revolution. The patriarchate is restored in the person of Tikhon, formerly Archbishop of Alaska and the Aleutian Islands.

December 8, Father John Kochurov, formerly priest in Chicago, is the first clergy-martyr of the Russian Revolution.

1919 — Second All-American Church Sobor (Council) elects Archbishop Alexander (Nemolovsky) as ruling archbishop.

First Assembly of the Albanian Diocese in America occurs, presided over by Bishop Alexander. Father Theophan Noli is elected bishop.

1921 — Archbishop Platon (now Metropolitan of Odessa and Cherson) returns to the United States.

Archbishop Meletios of Athens (later Patriarch of Constantinople) establishes the Greek Orthodox Archdiocese of North and South America.

1922 — Archbishop Alexander leaves the United States and the North American diocese.

Patriarch Tikhon is placed under house arrest by the Soviet government in Russia.

Censer — Russia, 18th century. Silver, brass, iron, embossed, gilded silver, 9×20 cm. Irkutsk Regional Museum (Cat. 24)

Icon: Christ Pantocrator —
Russia, 19th century. Wood,
paint, brass, silver, 17.8×14 cm.
BankAmerica Corporation

This icon of Christ is from an
unidentified church in the
Aleutian Islands. (Cat. 229)

Communion Set from Siberia

Paten, Star — Iak Vitaliev,
Moscow, 1801. Engraved, silver
gilding, enamel, rhinestones.
Paten, 12×29 cm.; Star, 15×19
cm. Irkutsk Regional Museum

Spoon — Moscow, 1801.
Silver gilding, 30×5 cm.
Irkutsk Regional Museum

Lance — Russia, early 19th
century. Silver gilding with
chasing, steel, 17.3×5 cm.
Irkutsk Regional Museum

This communion set from
Russia includes a paten, star,
spoon and lance. The enamel
miniature on the star, placed
at the point where the arches
cross, is a representation of the
Lord of Hosts. It is set with rock
crystal rays radiating from the
center. Around the outer edge
of the paten is engraved, "Lamb
of God, Take Away the Sins of
the World." On the handle of
the spoon is a representation
of the Crucifixion.
(Cat. 25, 26, 29, 30)

Metropolitan Platon is elected by American Orthodox Council as first ruling Archbishop of the Archdiocese of North America and Canada; he serves until his death in 1934.

Creation of the Diocese of Chicago and consecration of Priest Theodore Pashkovsky as Bishop Theophilus.

1923 — Seminary in Tenafly, New Jersey, is closed due to lack of funds.

1924 — The Council of the Orthodox Church in North America announces its administrative independence from Soviet Russia and becomes known as the Russian Orthodox Greek Catholic Church of North America. This status is not accepted by the Russian Church which establishes a rival hierarchy and lays claim to the Orthodox parishes, property, and the Orthodox Cathedral in New York City.

The Council appoints Metropolitan Platon as Ruling Bishop of All America and Canada.

1925 — Court of Appeals in New York state upholds the claim of Soviet-appointed "Archbishop" John Kedrovsky to control of the Orthodox Cathedral in New York City; Metropolitan Platon, although supported by most American Orthodox, is forced to vacate the cathedral.

Independent Syrian-Antiochian jurisdiction is formed.

1926 — Creation of the Diocese of Canada and consecration (in Belgrade) of Archimandrite Arseny as Bishop of Winnipeg.

1926 — Metropolitan Platon rejects the claims of the Synod of Russian Bishops in Exile (Synodal Church) to ecclesiastical authority over the American metropolia.

1927 — First convention of the Russian Orthodox Youth in Pittsburgh, Pennsylvania, and the founding of the Federated Russian Orthodox Clubs (FROC).

Archimandrite Emmanuel (Abo-Hatab), administrator of the Canadian Mission to Syrians is consecrated Vicar Bishop of Montreal.

Creation of Diocese of San Francisco and consecration of Archimandrite Alexy (Panteleev) as bishop.

1928 — Creation of Diocese of Detroit and consecration of Archimandrite Paul (Gavrilov) as bishop.

1929 — Metropolitan Platon, as Ruling Bishop of All America and Canada, on authority of the All-America Church Council, proclaims the Church in North America to be the North American Metropolitan District.

1931 — Metropolitan Platon rejects the request of Patriarch Sergius of Moscow to pledge "loyalty" to the Soviet regime.

1933 — Creation of the Diocese of Pittsburgh; Archimandrite Benjamin (Basalyga) is consecrated; he is the first American-born bishop in America.

Bishop Benjamin (Fedchenkov) arrives in America from Russia as patriarchal exarch. This begins the Moscow Patriarchal Exarchate in America.

1934 — Metropolitan Platon dies and Archbishop Theophilus (Pashkovsky) is elected metropolitan by the fifth All-American Church Sobor.

1935 — Vicariate created for Boston and consecration of Makary (Michael Iljinsky) as bishop.

March, Bishop Policarp (Morusca) is consecrated bishop of the new American Romanian Diocese under the jurisdiction of the Romanian Orthodox Church; the diocesan center is established in Detroit.

1938 — St. Vladimir's Seminary opens on October 3 in New York City.

St. Tikhon's Pastoral School opens in South Canaan, Pennsylvania.

1943 — First Orthodox chaplain is appointed in the United States Armed Forces.

Acquisition of Holy Virgin Protection Cathedral in New York City, as a spiritual and administrative center.

1944 — 150th anniversary of Orthodoxy in America is celebrated.

1946 — Bishop Benjamin of Pittsburgh is sent to Japan to assume the leadership of the Japanese Orthodox Church, which is placed under the spiritual protection of the North American Metropolia after World War II.

1948 — St. Vladimir's Seminary is reorganized as a theological academy (Graduate School of Theology) and St. Tikhon's Pastoral School is reorganized as a theological seminary.

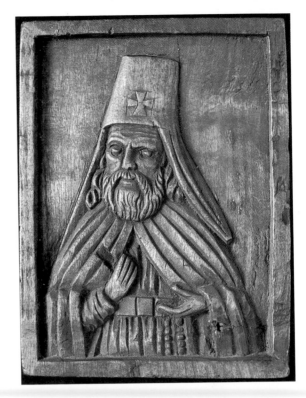

Icon: St. Mitrofoni, Bishop of Voronezh (d. 1703) — Russia, 19th century. Wood, incised, 13.5×10.3 cm. Irkutsk Regional Museum

(Cat. 69)

1950 — Metropolitan Theophilus dies on June 27.

Eighth All-American Church Sobor elects Archbishop Leonty (Turkevich) of Chicago Metropolitan of All-America and Canada.

1951 — Vicariate created for Washington, D.C. and consecration of Archimandrite Jonah as bishop.

1956 — A Pan-Orthodox Christian Education Commission is founded.

1960 — The Standing Conference of Canonical Orthodox Bishops (SCOBA) in the Americas holds its first meeting March 15 at the Greek Orthodox Archdiocese in New York.

Bishop's Panagia — Russian, 19th century. Mother-of-pearl, 14×6.5 cm. BankAmerica Corporation

The image of the Resurrection has been delicately carved in the mother-of-pearl. The panagia, part of a private collection of Alaskan Orthodox liturgical art, is thought to have belonged to Bishop (Saint) Innocent. (Cat. 231)

The Romanian Orthodox Episcopate is received by the Great Council of Bishops into the jurisdiction of the metropolia, March 31.

1962 — St. Vladimir's Seminary moves to Crestwood, New York, its present location.

1965 — Archbishop Ireney (Bekish) of Boston is elected metropolitan following death of Metropolitan Leonty.

Constance Tarasar graduates from St. Vladimir's Seminary, becoming the first woman in America to receive a graduate degree in Orthodox Theology.

1966 — Fire destroys St. Michael Cathedral, built in Sitka in 1844-1848 by Bishop Innocent (Veniaminov).

1969 — First episcopal consecration of a convert to Orthodoxy in America, when Archimandrite Dmitri (Royster) is consecrated Bishop of Berkeley, California, Vicar to Archbishop John of San Francisco.

1970 — The Canonical Status of Autocephaly (Independence) is granted on April 10 to the Russian Orthodox Greek Catholic Church of America, by the Mother Russian Church, and the Patriarchal Exarchate in America is ended. The Tomos is signed by Patriarch Alexis, who subsequently dies on April 16.

Official delegation of the Orthodox Church in America, headed by the Bishop of Sitka and Alaska, Theodosius, arrives in Moscow and receives the official Tomos of Autocephaly (Proclamation of Independence) from the Guardian of the Patriarchal Throne, Metropolitan Pimen; the American Church adopts the new name, Orthodox Church in America.

Father Herman is canonized, in Kodiak, as Saint Herman of Alaska, Wonder-worker of All America, and he becomes the first American Orthodox saint. His body is removed from the grave on Spruce Island and placed in the Church of the Holy Resurrection in Kodiak.

1971 — The Albanian Orthodox Archdiocese is received into the canonical jurisdiction of the Orthodox Church in America.

1972 — The Exarchate of Mexico is established to care for Mexicans received into Orthodoxy. Archimandrite Jose (Cortes y Olmos) is consecrated Bishop of Mexico City, Exarch and Auxiliary Bishop of Mexico.

1973 — St. Herman's Pastoral School is founded in Kenai, Alaska.

Discovery by Rev. Joseph P. Kreta and Bishop Gregory (Afonsky) of the pastoral journals of Rev. Jacob Netsvetov, missionary to the Eskimos, at Russian Mission, Yukon River, Alaska.

1974 — St. Herman's Pastoral School takes the name St. Herman's Orthodox Theological Seminary and is transferred to Kodiak, Alaska.

1976 — Reconstruction of St. Michael Cathedral in Sitka is completed and consecrated in November.

Bulgarian Diocese is received into the Orthodox Church in America.

1977 — Bishop Theodosius (Lazor) of Western Pennsylvania is elected Metropolitan of the Orthodox Church in America, following the retirement of

Metropolitan Ireney. He becomes the first American-born Primate of the Orthodox Church in America.

St. Herman's Pastoral School in Kodiak is accredited a Theological Seminary by the Synod of Bishops.

Metropolitan Innocent (Veniaminov) is canonized, St. Innocent of Moscow, Enlightener of the Aleuts and Apostle to America and Siberia.

1978 — The Diocese of the South is established.

1980 — Hieromonk Juvenaly and Peter the Aleut are canonized as locally venerated saints and Holy Martyrs in the Diocese of Alaska.

Creation of the Diocese of Washington, D.C. and transfer of the Metropolitan's see from New York to Washington, D.C.

1988 — Consecration of the newly restored Annunciation Chapel in the Russian Bishop's House, Sitka. This is the oldest Orthodox structure in North America, having survived since 1845.

Completion by the National Park Service of restoration of the Russian Bishop's House, Sitka. Purchased in 1973 by the Park Service, the structure is a National Historic Landmark.

1989 — Patriarch Tikhon of Moscow, formerly Bishop of North America, is canonized as St. Tikhon, Patriarch and Confessor of Moscow, Enlightener of North America.

Bishop Tikhon on a pastoral visit to Alaska in 1901 is flanked by clergy and Orthodox faithful. Left to right: Rev. Nicholas Kashevarov, Rev. Andrew Kashevarov (both of Aleut heritage) Bishop Tikhon, Mr. Popoff, and Rev. Tikhon Shalamov. In 1917, Tikhon was elected Patriarch of Moscow, the first to hold this position since 1721. In 1989, he was canonized as St. Tikhon Patriarch and Confessor of Moscow, Enlightener of North America. Photograph courtesy Alaska State Library.

1991 — November, Aleksy II, Patriarch of Moscow and All Russia makes a pastoral visit to North America. He is the first Russian Primate to visit the United States.

1993 — May, St. Herman's Orthodox Theological Seminary, Kodiak, celebrates it twentieth anniversary, noting the ordination of 19 Alaska Natives to the priesthood or diaconate and 21 graduates in all.

September, Patriarch Aleksy II of Moscow and all Russia, Metropolitan Theodosius of the United States, and a delegation of bishops visit Alaska and other U.S. sites to inaugurate the Bicentennial of Russian Orthodoxy in North America.

1994 — May 15, blessing of the St. Herman's Seminary Chapel, Kodiak, Alaska. This is a replica of the first Church of the Holy Resurrection built by the missionary party of 1794.

May 29-30, canonization at St. Tikhon's Monastery of Father Alexis Toth.

October, canonization in Russia of priests John Kochurov and Alexander Hotovitzky, missionary priests in North America, who were martyred during the Russian Revolution and its aftermath.

October 15-16, canonization of the Alaskan Aleut priest, Father Jacob Netsvetov, in services in Anchorage, Alaska.

Church of the Holy Ascension, Unalaska Island, Alaska, ca 1910. Built in 1896, this church is a National Historic Landmark. The Unalaska parish was founded by Father John (Ioann) Veniaminov, Saint Innocent, in 1824, and the church contains many design features of its first pastor as well as his personal effects, including his own copy of the Gospel in Aleut, the translation of which he had provided. Photograph from the J. N. Wyman Collection, Anchorage Museum of History and Art.

(Opposite)

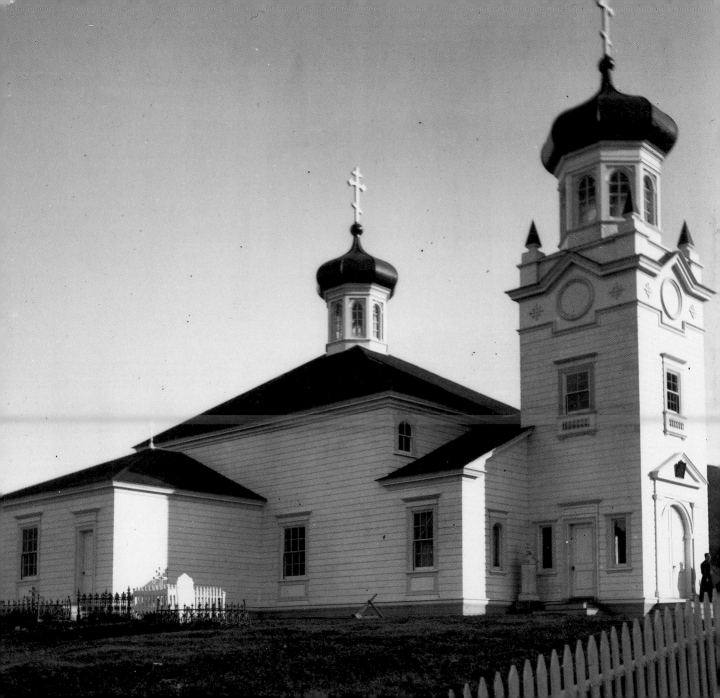

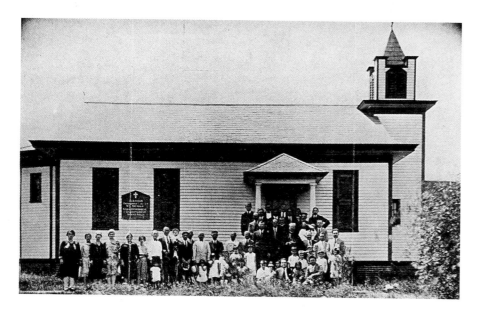

St. Nicholas Albanian Orthodox Church, Southbridge, Massachusetts. It was in this church in 1912 that the Divine Liturgy was served in the Albanian language for the first time, under the leadership of the great cleric-scholar-diplomat, Father Fan Noli. Photograph courtesy Archives, Orthodox Church in America.

St. Herman's Seminary has trained more than 20 Native Orthodox clergy. Among them are (bottom row) Martin Nicolai (left) and David Askoak; top row Stephen Heckman (left) and Peter Askoar. Photograph courtesy St. Herman's Theological Seminary.

GLOSSARY

aer also called a veil or vozdukh; a large, rectangular cloth that covers both chalice and star on the paten

antimins a silk or linen cloth essential to celebration of Divine Liturgy; it has the image of Christ's entombment and the four Evangelists. Holy relics are sewn into the cloth and it is placed on the altar and can be used when an altar is not available. When churches are consecrated, they are presented with an antimins.

archimandrite administrator of several monasteries; also a raise in rank for a monk signifying both honor and increased responsibilities

archpriest a title of distinction with additional authority

belt also called a zone; it is symbolic of the gift of strength which God bestows on his clergy to aid them in their service

bishop the head of a diocese with authority to ordain priests; must have taken monastic vows

censer an ornamental container in which incense is burned; it is kept in the sanctuary of the church and is used during the liturgy to cense the icons and the congregation; it is the desire that prayers offered might be lightly wafted to Heaven like the smoke of the incense

chalice or potir; a cup used for Holy Communion; the wine and bread are offered together in the chalice to the communicants and are administered by spoon

cross the Orthodox typically use a three-barred cross; traditionally, the lower angled bar is believed to represent the agony of Christ's death, showing that He experienced true suffering. Another tradition holds that the upward thrust of the bar recalls "the good thief" who confessed Christ as Savior while they both were being crucified and was assured that he would be with Him in Heaven.

cuffs or maniples, are worn by the priest around the wrists and fastened with cords; they serve as a reminder that all classes of ordained persons must hope and rely on God's help

daranositsa literally means, "gift carrier"; it is used to transport the Eucharist to parishioners unable to attend services

deacon the first order of ordained clergy; he may assist the priest and may conduct all services except the Holy Eucharist

Deesis a type of iconographic composition with the depiction of Christ Pantocrator in the center and, on the sides appealing to him, the Mother of God, John the Baptist, the Archangels Michael and Gabriel, Apostles Peter and Paul and other saints; it also is the name given to the tier of an iconostas with these images

dikiri a double branched candlestick representing the dual nature of Christ (human and divine); it is used by a bishop to bless the congregation

diocese an administrative division of the Church, headed by a bishop

epitrakhil or double stole, worn by priests and bishops; no service can be celebrated without this stole; it passes around the neck, is joined in front (sewn or buttoned) and falls low on the cassock; it typifies the consecrating grace of the priesthood and the complete devotion of the wearer to the Church

Eucharist Holy Communion, in which bread and wine are offered to the faithful following a ceremony of conse-cration; it is the principal sacrament of the liturgical churches; it is also termed the "Holy Mysteries" and the bread and wine are also known as the "Holy Gifts"

exarchate the representative of a church in another country claiming jurisdiction over a church

icon a form of religious art associated with Orthodox Christian Churches; the icon has been described as "a window into Heaven," or a gateway to the mystery of Orthodox spirituality. Its subjects are usually Christ, Mary the Mother of God, saints, or scenes from the life of Christ. The image is intended to transmit the teachings and traditions of the Church. The oldest and most traditional are made of wood and tempera paint on gesso ground, but they may also be painted or printed on canvas, cloth and paper; icons also may be fashioned from metal, ivory, and other natural substances.

iconostas a partition or wall across one end of the nave, symbolically uniting Heaven (the sanctuary) and earth (the nave); icons are placed on it in tiers; the center of the iconostas is marked by a pair of **Royal Doors** which open before the altar and on which are placed icons of the four Evangelists and the Annunciation; only ordained clergy may pass through these doors; others use the side doors at either end of the iconostas, the **Deacons' Doors** which have icons of sainted deacons or archangels on them

lance a spear-shaped knife which is used in the prepar-ation of Holy Communion; this double-edged knife is used to cut out portions of the bread to be placed in the chalice with the wine; it symbolizes the spear which pierced the dying Christ

liturgy a term deriving from the Greek which implies a public duty, the public rite of worship; liturgy in the Church includes a ritual involving thanksgiving, invita-tion, consecration of the bread and wine, and presenta-tion of the Holy Gifts to the faithful who come forward to receive them at the hand of the priest

metropolitan in Russian Orthodoxy, a bishop designated as leader, or primate, of the Church within a capital or region; from 1721 to 1917, the Metropolitan of Moscow was the Primate of the Orthodox Church in all of Russia. In the United States, the Metropolitan is the leader of all Orthodox within the jurisdiction of the Orthodox Church in America, successor to the original missionary party which landed in Alaska in 1794. He is elected by the Council of the Church (laity and clergy) and must be approved by the Synod or Council of Bishops. He is administrative leader of the nine dioceses of North America, chairman of the Church's governing body (its council), and also is archbishop of Washington, D.C.

miter an ornamented, cloth crown conferred upon bishops, archimandrites, and certain archpriests; it serves to remind the clergyman both of the power bestowed upon him and of Christ's suffering under His crown of thorns; it is normally decorated with four icons: Christ, Mother of God, John the Baptist and the Crucifixion

oklad a decorative cover for an icon, generally with open areas to expose the face, hands and feet of the figures; often made of silver, gold or copper alloys, but also made of other materials such as textile with embroidery, pearls, gems, etc.

omofor also known as a stole or pall; a long broad cloth strip, adorned with crosses, worn by bishops over the shoulders on top of all their other vestments; it serves as a reminder that the bishop, like a merciful shepherd who takes the straying sheep upon his shoulders is concerned with the salvation of the errant

orar or stole; a long wide strip, decorated with a fringe, braid or embroidery and worn on top of the stikhar; deacons wear it on the left shoulder and, on certain occasions, bind it around their bodies crosswise, typifying the wings of the angels who serve about the altar, as the deacons themselves typify the Cherubim and Seraphim; sub-deacons wear the garment crossed on the shoulders or tied under one shoulder; it symbolizes the grace of the Holy Spirit which flows down upon the ordained

palitsa also called an epigonation; a priest's vestment, normally worn by an archpriest and given as an award and recognition of high rank; it is a diamond-shaped cloth worn on the right hip signifying the spiritual sword

panagia a small, richly decorated, round or oval iconographic image of the Savior or the Mother of God worn as a pendant by bishops; *panagia* is Greek for "all-holy"

paten sometimes called the disk or diskos; a small round dish on which portions of bread are laid in preparation for Holy Communion; it is used with the protective "star" which covers the bread

patriarch the title of honor given to the head of an Orthodox Church which is autonomous in its internal government. The four ancient patriarchs of the Orthodox Church remain Constantinople, Antioch, Jerusalem, and Alexandria. In 1589, the Russian Orthodox Primate was also designated a patriarch. This office was eliminated by Tsar Peter the Great of Russia in 1721 and not restored until 1917. The heads of the Serbian, Bulgarian, and Romanian Churches also are patriarchs today. A patri-

arch does not have power to set doctrine or pronounce dogma. The position is honorary, as well as administrative; he is the "first among equals."

phelon also called chausable or robe; a long cape-like garment cut away in the front with decorative bands; it is worn over other vestments

plashchanitsa a large cloth icon of Christ Entombed and covered with a winding sheet; it is placed on the altar for veneration from Good Friday until midnight on Holy Saturday

podriznik also called an alb or cassock; it is worn as the undergarment for other vestments; it is made of fine white fabric; the sleeves are narrow with laces that can be tightened at the wrists; the white color reminds the priest that he should always have a pure spirit and lead an exemplary life; it also serves as a reminder of the robes worn by Christ as he went about his work for man's salvation

priest a rank of clergy, ordained by the laying on of hands of two or more bishops. In the Orthodox Church a priest must be married unless he has taken a vow of celibacy as a monk.

riza thin, decorative metal sheets nailed to, or otherwise placed on certain sections of a painted surface to embellish or emphasize selected features or figures of an icon

sakkos or dalmatic; a mid-length bishops' tunic with short sleeves or half sleeves; sakkos means a "sackcloth garment" or "garment of humility"; it is woven from top to bottom without a seam, symbolic of Christ's seamless cloak; it serves as a reminder that the wearer must strive toward a holy life

staff also called crozier or paterissa; a staff, given to bishops and archimandrites (heads of monasteries); the top of the staff usually has a cross flanked by two serpents bending upward; it symbolizes the bishop's role as shepherd of Jesus' flock, while the serpents represent wisdom

star also called the asterisk; it is made of two arched bands which stand on the paten; they form the shape of a cross or star and are fastened in the middle; the bands can also be moved together to form a single arc; it is used to protect the bread on the paten when the aer is placed on top; it symbolizes the star that appeared at Christ's Nativity

stikhar also referred to as a dalmatic; it is a full-length vestment with wide sleeves; it covers the whole person and signifies "a robe of salvation and the garment of joy"; it symbolizes a pure and tranquil conscience, a spotless life and spiritual joy

sulok the sulok is two identical layers of fabric, tied around the upper part of the bishop's staff; it is possible that the sulok was introduced into services for practical reasons; the lower layer of the sulok would protect the hand from the cold metal and the upper from external cold; in the summer it provided the bishop with a cloth to wipe his brow

tabernacle also called the ark or ciborium; it is a container, often in the shape of a church, with several

small compartments; it is placed on the altar and is used for storing the Eucharistic bread and wine for use between liturgies

Table of Oblation a table, behind the iconostas, to the north of the altar; it is decorated with ornate cloths upon which are placed vessels and objects used to prepare the bread and wine for Holy Communion

trikiri a triple branched candlestick representing the Holy Trinity; it is held by a bishop with the dikiri and is used to bless the congregation

tropar the earliest form of Byzantine hymn to the Lord, Mother of God, or the saints, pertaining to special feasts or occasions

veil or pokrov, aer or vozdukh; a cloth used to protect the Holy Gifts; during the Holy Liturgy three veils are used; one small veil covers the chalice, another covers the paten with the star, and a third larger veil covers them all

vestments the garments worn by clergy during a church service. The process of "vesting" a bishop during his entrance into the church is done before the congregation, with each garment having the symbolic weight of the responsibility of his office.

vicariate an administrative division within a diocese, headed by a bishop who is auxiliary to the bishop of the diocese

vinetz a halo-like crown sometimes separately attached above the heads of figures on an oklad

LENDERS

"Heaven on Earth: Orthodox Treasures of Siberia and North America," an exhibition organized by the Anchorage Museum of History and Art, was made possible through the willingness of the following museums, churches, and individuals to lend important religious artifacts:

Vladislav Andrejev
Highland Mills, New York

BankAmerica Corporation
Seattle, Washington

Dennis Bell
Painesville, Ohio

Byron Birdsall
Anchorage, Alaska

Mr. and Mrs. William Carr
Anchorage, Alaska

Cathedral of the Holy Protection
New York City

Church of the Advent of Christ the King (Episcopal)
San Francisco, California

Reverend Luke Dingman
Brookdale, California

Diocese of New England
Orthodox Church in America

George Dobrea
Cleveland, Ohio

Kenneth Dowdy
Hebron, Indiana

Fort Ross Interpretive Association
Jenner, California

Greek Orthodox Cathedral of the Ascension
Oakland, California

Bishop Gregory (Afonsky)
Sitka, Alaska

Holy Ascension Orthodox Church
Unalaska, Alaska

Holy Assumption of the Virgin Mary Orthodox Church
Kenai, Alaska

Holy Protection of the Mother of God Orthodox Church
Santa Rosa, California

Holy Resurrection Serbian Orthodox Cathedral
Chicago, Illinois

Holy Trinity Greek Orthodox Cathedral
New Orleans, Louisiana

Holy Trinity Orthodox Cathedral
Chicago, Illinois

Holy Trinity Orthodox Cathedral
San Francisco, California

Irkutsk Regional Museum
Irkutsk, Russia

The James Family
Anchorage, Alaska

Vladimir Krassovsky
Pacifica, California

Very Reverend Nicholas Molodyko-Harris
Anchorage, Alaska

Deacon Victor Nick
Kwethluk, Alaska

Orthodox Church in America, Primatial Vestry
Syosset, New York

Provincial Museum of Alberta
Edmonton, Alberta, Canada

Romanian Ethnic Art Museum
Cleveland, Ohio

St. Alexander Nevsky Orthodox Chapel
Akutan, Alaska

St. George the Victorious Orthodox Church
St. George, Alaska

St. Herman's Orthodox Theological Seminary
Kodiak, Alaska

St. John the Evangelist Orthodox Cathedral (Antiochian)
Eagle River, Alaska

St. John of Damascus Sacred Art Academy
Antiochian Village, Ligonier, Pennsylvania

St. Mary's Romanian Orthodox Church
Cleveland, Ohio

St. Michael Cathedral
Sitka, Alaska

St. Nicholas Orthodox Church
Juneau, Alaska

St. Photius National Greek Orthodox Shrine
St. Augustine, Florida

St. Sergius Chapel, Chancery, Orthodox Church
in America, Syosset, New York

St. Vladimir's Orthodox Theological Seminary
Crestwood, New York

St. Tikhon's Monastery
South Canaan, Pennsylvania

Philip Tamoush
Torrance, California

Three Saints Church
Old Harbor, Kodiak Island, Alaska

Rev. Andrew Tregubov
Claremont, New Hampshire

Sam Young
Anchorage, Alaska

CREDITS

Heaven On Earth:
Orthodox Treasures of Siberia and North America

Catalog Design: Ayse Gilbert
Typesetting: Julia Hall, Typographiques
Photography (unless noted): Chris Arend
Publication Management: Jim Krebs
Color Separations: Norstar Color
Printing: Northern Printing
Staff, Irkutsk Regional Museum: Elena A. Dobrynina, Lidiia I. Askarova,
 Galina A. Karpova, Svetlana E. Belaia, Aleksandra K. Nefed'eva,
 Irina V. Mozgovaia, Tamara S. Nebytova
Staff, Irkutsk Regional Art Museum: Tamara A. Kriuchkova

To all the skilled people who worked so diligently in the production of this catalog,
we extend our heartfelt thanks and appreciation.